SANDRA MÜLLER

DOG PEOPLE

teNeues

83 DOGS
AND A PANOPLY OF
HUMAN PERSONALITIES

83 HUNDE
UND EIN PANOPTIKUM
MENSCHLICHER CHARAKTERE

83 CHIENS
ET UN POT-POURRI
DE CARACTÈRES HUMAINS

FOREWORD BY SANDRA MÜLLER

No, this book is not meant to be a fashion show for dogs and dog owners – dogs are not dolls and should only have clothes put on them when it is medically necessary. This book is simply a thought experiment: what kind of person would my dog be? And let's be honest; every dog lover has anthropomorphized his dog at some point: "He always looks so sad when we leave," or "When he hears his master coming home, he laughs." And who hasn't given his or her dog a lengthy explanation which the dog seems to listen to raptly but surely doesn't understand every word of? Yes, yes, I know... YOUR dog understands every word, just like mine!

So how did I get the idea for this book? It all started when I ordered some clothes online and my dog Maja watched with interest when I opened the package and sniffed curiously at each item. Maja, by the way, is a Bernese Mountain Dog mix, definitely not the kind of dog who enjoys wearing clothing. But as we were sitting there on the floor together, I jokingly asked her (totally humanizing her, by the way), "So, which one would you like?" Other than her ears pricking up a bit, I didn't get an answer. But I still told my friends about it as we walked our dogs together. I live in the country, and dogs in our area tend to be very sporty dogs who are outside a lot and never wear clothing. But most of the owners could definitely follow my thoughts on this – even if it was just to get a snapshot for their Christmas card. And suddenly I knew that I had stumbled on the perfect topic for my term project. I am studying design with a concentration in photography, and in my sixth semester, we had to complete an independent project that would be a "meaningful

addition to our portfolio." Well, I had already specialized in portraits of people (and dogs), but I was looking for a new approach that would "meaningfully expand" my portfolio, and now here it was: "If they were human, how would our dogs look, and what kind of people would they be?"

Of course, I started with Maja, because she knows my photo studio (and me) and is completely relaxed in that environment. I used her to figure out how to get the best results in the least time. I didn't want the shoots to be torture for the dogs, and I didn't want to simply cram them into an outfit. But magically Photoshopping the clothes on didn't seem right either, because the transition from clothing to fur would look fake. And it was also interesting to observe how the dogs reacted to the situation. The simplest solution on all counts looked like this: I prelit and prefocused each shot beforehand. All the dog had to do was sit (which truly bewildered one female: Sit? What's that?) and I would put a shirt, a jacket, a scarf, or something similar on the dog. If the dog didn't mind it, I might add a hat or a necklace before pressing the shutter button a few times, all the while rustling a bag of treats above the camera. The whole process took no more than two or three minutes per dog.

How did I find all of the different personalities? I already knew the initial group of dogs and owners, so I had a rough idea of who they were and could talk directly to each master or mistress about how they saw their dogs. I also put out a call on Facebook – and got applications from over 300 dog owners. I didn't need that many for my term project, but when Hendrik teNeues

approached me with the idea of making a book, I did go back and use many of these applicants. The owners had all included information about their dog's size, breed, and age, and described what made their dog special. But what surprised me was that some people could go on for two pages about their dogs, while others included nothing but the facts. I mean, hey, if I had to describe Maja to someone, I would probably bore them to tears because I can go on forever about how special she is. And while we're talking about Maja, I have to beg your forgiveness in advance because I crowned her "Miss Dog People". But I think any dog owner will forgive me, because we all know your own dog is ALWAYS the best and most beautiful.

At any rate, I looked at the photos and descriptions people sent in and thought about how people might see the dog in question and whether and where I could find an appropriate outfit. For the two dogs I dressed as wounded soldiers, that wasn't easy at all. Because their stories were very serious and not merely funny like most of the others, I didn't want to use Halloween costumes. It is no easy task to get your hands on approved real uniforms, but I eventually managed it. I also thought it was important to make each portrait one that honestly captures a type of person, a human being you could actually meet. For example, one owner said her dog would look very strange as Superman. I totally believe her – but that wasn't really what it was about. The focus was always this: If this dog were a person, what sort of person would he or she be?

The vast majority of the dogs were very chill during their photoshoots and enjoyed being the center of attention. There were only two animals who were clearly stressed. One of them demonstrated this by depositing a large pile in the middle of the studio, and the other just started panting nervously. Of course, I immediately stopped in both cases. Like I said, this was not Germany's Next Dog Model, and I did not want to make any dog prove how much he or she could endure.

Oh, yes, and after I finished with each dog, they got an owner-approved treat. I think some of them would have been willing to stay still even longer for their goodies, but treats aside, many of the dogs absolutely floored me with their patience. For these and other anecdotes, the personalities of our protagonists, and my reasons for choosing the outfits I did, just see the text next to each portrait. For most of the dogs, I also put a quote of my own devising into their mouths. And now, I hope you enjoy Dog People!

Sandra Müller

VORWORT SANDRA MÜLLER

Nein, dieses Buch soll keine Modenschau für Hunde und Hundebesitzer sein – Hunde sind keine Puppen und sollten eigentlich nur dann angezogen werden, wenn es medizinisch notwendig ist. Dieses Buch ist einfach ein Gedankenexperiment: Was für ein Mensch wäre mein Hund? Und seien wir ehrlich: Jeder Hundefreund hat schon mal zumindest seinen eigenen Hund vermenschlicht: „Er schaut immer so traurig, wenn ich gehe", oder „Wenn er hört, dass Herrchen nach Hause kommt, dann lacht er". Und wer hat seinem Hund nicht schon Dinge ausführlich erklärt, denen dieser sehr aufmerksam gelauscht, die er aber sicher nicht wortwörtlich verstanden hat? Jaja, ich weiß schon. IHR Hund versteht jedes Wort! Genau wie meiner!

Wie also kam es aber zu diesem Buch? Eigentlich fing alles damit an, dass ich mir selbst etwas zum Anziehen bestellt hatte und mir meine Hündin Maja beim Öffnen des Päckchens interessiert zuschaute und jedes Teil neugierig abschnüffelte. Maja ist übrigens ein Berner-Sennenhund-Mix und gehört als solcher sicher nicht zu den Hunden, die gerne mal angezogen werden. Als wir aber beide so am Boden saßen, fragte ich sie im Scherz – und natürlich total vermenschlichend: „Na, was würde dir denn gefallen?" Außer hochgestellten Ohren bekam ich keine Antwort. Aber ich erzählte Freunden beim gemeinsamen Gassigehen davon. Ich wohne auf dem Land, unsere Nachbarhunde sind in der Regel sehr natürliche Hunde mit viel Auslauf und wenig Kleidung. Die meisten Besitzer aber kannten solche Überlegungen wie meine durchaus – und sei es nur für die jährliche Weihnachtskarten-Produktion. Und plötzlich wurde mir bewusst, dass ich damit genau das Thema für meine Semesterarbeit gefunden hatte.

Ich studiere Design mit Schwerpunkt Fotografie und dafür mussten wir im sechsten Semester ein freies Projekt entwickeln, das „unser Portfolio sinnvoll erweitern" sollte. Naja, bisher hatte ich mich auf Porträts von Menschen (und Hunden) spezialisiert, war aber noch auf der Suche nach einem neuen Ansatz für die erwähnte „Portfolio-Erweiterung". Jetzt hatte ich sie gefunden: „Wie würden unsere Hunde aussehen, was für ein Typ wären sie als Mensch?"

Ich habe natürlich mit Maja angefangen, da sie mein Fotostudio (und mich) kennt und sich darin völlig entspannt bewegt. Also konnte ich mit ihr ausprobieren, wie ich am schnellsten zu den besten Ergebnissen kam. Ich wollte ja die Aufnahmen nicht zur Qual für die Hunde machen oder sie einfach in irgendwelche Kleidungsstücke zwängen. Alles aber nur digital zu bearbeiten, fand ich auch nicht gut. Man sieht dann, dass der Übergang von Kleidung und Fell nicht natürlich ist. Irgendwie war es auch interessant, die Hunde zu beobachten, wie sie auf die Situation reagierten. Die für alle einfachste Lösung sah dann so aus: Alle Belichtungs- und Schärfen-Einstellungen bereitete ich vor. Der Hund (oder die Hündin) musste sich nur setzen (was tatsächlich bei einer Hündin zu großem Unverständnis führte: Sitz! Was heißt das?), und ich legte ihm ein Hemd, eine Jacke, einen Schal oder ähnliches um. Wenn der Hund kein Problem damit hatte, kam eventuell noch ein Hut oder eine Kette dazu, dann habe ich ein paar Mal auf den Auslöser gedrückt (und dabei mit einer Leckerli-Tüte über der Kamera geknistert) – und zwei bis drei Minuten später waren wir fertig.

Wie ich zu den einzelnen Typen kam? Die ersten Hunde und ihre Besitzer kannte ich ja schon, hatte also schon eine bestimmte Vorstellung und konnte direkt mit den Herrchens oder Frauchens sprechen, wie sie denn ihre Hunde sahen. Außerdem startete ich einen Aufruf über Facebook – und bekam Bewerbungen von über 300 Hundebesitzern. Für meine Semesterarbeit brauchte ich natürlich nur eine begrenzte Zahl. Als jedoch Hendrik teNeues mit der Idee zu diesem Buchprojekt auf mich zukam, konnte ich auf diese Bewerbungen zurückgreifen. Die Besitzer beschrieben schon einmal vorab Größe, Rasse, Alter und beantworteten mir die Frage, was ihren Hund besonders macht. Was mich dabei erstaunt hat: Manche konnten mir zwei Seiten zu ihrem Hund schreiben, manche außer den bloßen Fakten nichts. Also, wenn ich jemandem Maja beschreiben müsste... würde ich wahrscheinlich jeden langweilen, weil mir so viel Besonderes an ihr einfällt. Apropos Maja, ich muss mich an dieser Stelle schon einmal vorab entschuldigen, weil ich Maja zur „Miss Dog People" gekürt habe. Aber ich denke, jeder Hundebesitzer wird es mir verzeihen. Der eigene Hund ist IMMER der schönste.

Jedenfalls überlegte ich mir dann anhand der Vorabfotos der Hunde und ihrer Beschreibungen, wie man den entsprechenden Rüden oder die Hündin sehen und ob und wie ich das entsprechende Outfit finden könnte. Bei meinen beiden kriegsversehrten Soldaten war das zum Beispiel gar nicht so einfach. Da deren Geschichte sehr ernst und nicht einfach lustig wie bei den meisten anderen ist, wollte ich keine Faschings-Uniformen verwenden. Es ist aber gar nicht so leicht, an genehmigte echte Uniformen zu kommen. Aber irgendwann war

auch das geschafft. Wichtig war mir auch, dass es sich bei den einzelnen Typen wirklich um Typen handelt, die eben auch unter Menschen vorkommen. Eine Besitzerin hatte mir beispielsweise erklärt, ihre Hündin sähe als Superman sehr komisch aus. Das glaube ich ihr aufs Wort – aber genau darum ging es ja nicht. Sondern immer um die Frage: Wenn dieser Hund ein Mensch wäre, was für ein Typ wäre er dann?

Die allermeisten Hunde waren beim Shooting total entspannt und haben die Aufmerksamkeit, im Mittelpunkt zu stehen, genossen. Nur zweimal waren die Tiere offensichtlich gestresst. Einmal wurde das mit dem Absondern eines großen Haufens mitten im Fotostudio demonstriert und einmal einfach damit, dass die entsprechende Hündin anfing, nervös zu hecheln. Natürlich habe ich dann sofort abgebrochen. Wie gesagt, ich wollte keine Foto-Shootings mit Germanys Next Dog Models machen, die beweisen müssen, wieviel sie aushalten.

Ach so, und natürlich hat jeder Hund nach dem Shooting ein mit dem Besitzer abgesprochenes Leckerli bekommen. Ich glaube, der eine oder andere hätte dafür auch noch länger stillgehalten. Manche Hunde waren aber ohnehin so geduldig, dass ich selbst gestaunt habe. Diese und andere Anekdoten, die Eigenschaften der Protagonisten und meine Beweggründe für die Auswahl der Kleidung finden sich in den Texten zu jedem Bild und dazu meistens noch ein Spruch, den ich dem Porträtierten einfach mal ins Maul gelegt habe. Und jetzt viel Spaß mit den Dog People.

Sandra Müller

PRÉFACE DE SANDRA MÜLLER

Non, ce livre n'est pas un défilé de mode canin à l'intention de leurs maîtres – les chiens ne sont pas des poupées et ne devraient être vêtus qu'à des fins médicales. Ce livre est simplement une expérience de pensée : Quel genre d'humain serait mon chien ? Et soyons honnêtes : quel maître n'a pas prêté des sentiments humains au moins à son propre chien : « Il a toujours l'air tellement triste quand je m'en vais » ou bien encore « Quand il entend que son maître rentre à la maison, il commence à rire ». Et qui n'a pas déjà expliqué longuement les choses à son chien qui, bien entendu, a très attentivement prêté l'oreille, même s'il n'a pas exactement compris tous les mots? Oui oui, je sais bien. VOTRE chien comprend tout ! Exactement comme le mien !

Mais comment en suis-je arrivée à écrire ce livre ? En fait, tout a commencé par la réception d'un colis contenant des vêtements que je m'étais commandés. Ma chienne Maja m'a regardée ouvrir ce colis avec intérêt et, curieuse, a reniflé toutes les tenues. Maja est un bouvier bernois mâtiné et, par nature, ne fait certainement pas partie de ces chiens qui acceptent d'être vêtus. Mais nous étions là toutes les deux assises par terre et je n'ai pu m'empêcher de lui demander pour plaisanter – et lui prêtant en cela des sentiments très humains : « Et toi, ça te plairait, ça ? » Ses oreilles se sont dressées, mais cela a été sa seule réponse. J'ai raconté la scène à des amis avec qui je vais régulièrement promener ma chienne. J'habite à la campagne et les chiens de nos voisins sont en général des chiens très nature qui ont l'habitude du grand air et ne sont jamais habillés. La plupart des maîtres connaissaient très bien le genre de réflexions que j'avais eues – ne serait-ce que pour la production annuelle de cartes de Noël. Et d'un coup, j'ai compris que j'avais trouvé le sujet de mon mémoire.

Je suis étudiante en design avec option photographie et, au cours du sixième semestre, nous devons concevoir librement un projet censé « élargir notre portfolio d'une manière sensée ». Jusque-là, je m'étais plutôt concentrée sur des portraits d'humains (et de chiens), mais j'étais toujours à la recherche d'une bonne idée pour « l'élargissement de mon portfolio » mentionné. Je l'avais donc trouvé : « À quoi ressembleraient nos chiens, quel genre d'humains seraient-ils ? »

J'ai bien évidemment commencé avec Maja, car elle me connaît moi et mon studio photo et était donc tout à fait relax. J'ai donc pu faire différents essais sur la manière de parvenir le plus vite possible aux meilleurs résultats. Je ne voulais pas que les photos soient une torture pour les chiens ou les forcer à enfiler je ne sais quels vêtements. Mais je ne trouvais pas génial non plus de ne travailler qu'en numérique. On aurait très bien vu que le passage de la fourrure au vêtement n'était pas naturel. Quelque part, il était aussi très intéressant d'observer comment les chiens réagissaient à la situation. Pour finir, la solution la plus simple pour tous était la suivante : je préparais d'abord tous les réglages d'exposition et de mise au point. Le chien (ou la chienne) devait juste s'asseoir (ce qui a vraiment provoqué l'incompréhension pour l'une des chiennes : Assis ! Qu'est-ce que cela signifie ?) et je lui mettais alors une chemise, une veste, une écharpe ou autre chose. Lorsque le chien ne faisait pas de problème, j'ajoutais parfois encore un chapeau ou un collier, puis j'appuyais un couple de fois sur le déclencheur (tout en froissant un paquet de friandises au-dessus de l'appareil) – et deux à trois minutes plus tard, le tour était joué.

Comment ai-je choisi les différents types ? Je connaissais déjà les premiers chiens et leurs maîtres, j'avais déjà une idée assez précise de ce que je voulais écrire et j'ai ainsi pu demander directement au maître ou à la maîtresse comment ils voyaient leur animal. Et puis, j'ai lancé un appel sur Facebook – et reçu les candidatures de plus de 300 propriétaires de chiens. Pour mon mémoire, je n'avais cependant besoin que d'un nombre limité. Mais lorsque Hendrik teNeues est venu me soumettre cette idée de livre, j'ai pu recourir à ces candidatures. Les maîtres et maîtresses devaient d'abord décrire leur chien (taille, race, âge) et répondre à la question de savoir pourquoi leur animal était particulier. Une chose m'a particulièrement étonnée : certaines personnes ont écrit deux pages sur leur chien, certaines autres n'ont rien trouvé à ajouter aux données pures. Moi si je devais décrire Maja... j'ennuierais certainement des quantités de gens car je trouverais plein de choses qui la rendent si spéciale. Concernant Maja, je suis ici désolée de signaler que je lui ai décerné le titre de de « Miss Dog People ». Mais je suis convaincue que tous les propriétaires de chiens me pardonneront. Son propre chien est TOUJOURS le plus beau.

Quoi qu'il en soit, j'ai d'abord réfléchi en regardant les photos des chiens et les descriptions sur la manière dont on pouvait s'imaginer le chien ou la chienne et comment trouver ce qui lui conviendrait le mieux comme tenue. Pour mes deux soldats mutilés de guerre, la chose n'a pas été facile du tout. Comme leur histoire était vraiment dramatique et pas simplement drôle, comme dans la plupart des autres cas, je ne voulais pas utiliser des uniformes de carnaval. Mais il n'est rien moins que facile de trouver de vrais uniformes autorisés. Cela a pris son temps, mais j'y suis parvenue. Pour moi, il était aussi important que pour les différents types, il s'agisse vraiment de types que l'on trouve aussi chez les humains. Une propriétaire m'a par exemple expliqué que sa chienne avait l'air très drôle déguisée en Superman. Je l'ai crue sur parole – mais la question n'était pas là. Bien plutôt : Si ce chien était une personne, quel type serait-il ?

La plupart des chiens étaient parfaitement relax pour le shooting et ont savouré le fait d'être au centre de l'attention. Par deux fois seulement, les animaux se sont montrés manifestement stressés. Une fois, cela s'est traduit par un gros tas en plein milieu du studio photo ; une autre fois, la chienne en question a commencé à haleter nerveusement. Évidemment, j'ai alors tout de suite interrompu. Comme je l'ai déjà précisé, je ne voulais pas d'un shooting genre top model version canine qui doit prouver tout ce que l'animal peut endurer.

Je tiens également à préciser qu'après le shooting, tous les chiens ont eu droit à une friandise convenue auparavant avec leur maître. Et je crois bien que l'un ou l'autre serait resté encore plus longtemps tranquille pour mériter sa récompense. Certains chiens se sont néanmoins montrés si patients que j'en ai moi-même été sidérée. Je mentionne cet aspect, ainsi que d'autres anecdotes, les propriétés des protagonistes et les réflexions concernant le choix de leur tenue dans chacun de mes petits textes accompagnant la photo ; j'y ai souvent ajouté une devise qui aurait pu sortir tout droit de leur gueule. Je vous souhaite un excellent moment en compagnie de mes Dog People !

Sandra Müller

ABBY VON DER ERZGRUBE

If Abby were human... she'd surely be a pilot. Not just because she is a giant Great Dane who always sees the big picture, but also because she keeps her cool in any situation even though she is only two years old. Nothing fazed her during our photoshoot. Airline passengers would always feel safe with her. "Captain and crew, ready for take off!"

Wäre Abby ein Mensch... wäre sie sicher Pilotin. Nicht nur, weil sie als Dogge natürlich ohnehin riesengroß ist und damit immer den Überblick hat, sondern auch, weil sie trotz ihrer erst zwei Jahre in jeder Situation gelassen bleibt. Auch beim Fotoshooting hat sie nichts aus der Ruhe gebracht. Da wären auch Flug-Passagiere immer gut aufgehoben. „Captain and crew, ready for take off!"

Si Abby était un humain... elle serait certainement pilote. Pas seulement à cause de sa grande taille de dogue qui lui permet d'avoir une vue d'ensemble, mais aussi parce que malgré son jeune âge (2 ans), elle reste sereine dans toutes les situations. Pendant le shooting, elle ne s'est à aucun moment départie de son calme. Rien de tel pour mettre des passagers en confiance. « Captain and crew, ready for take off. »

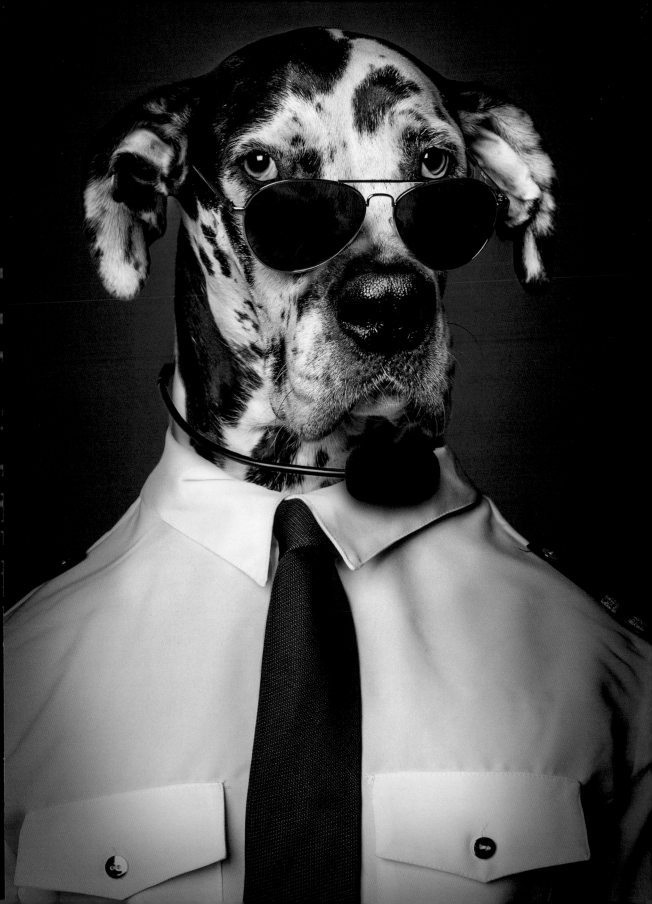

AKHIRO VOM BROMBACHSEE

If Akhiro were human... he would be a sweet, reserved gentleman. But Akhiro hasn't always had the greatest life. If you look closely, you can see old wounds from an iron rod on his muzzle and eye. He was also bitten as a nine week-old puppy, so he is a bit fearful sometimes, but he is always on his best behavior and adores children above all else. "Manners are important in life."

Wäre Akhiro ein Mensch... wäre er ein lieber, zurückhaltender Gentleman. Aber schön war das Leben für Akhiro nicht immer. Wer genau hinschaut, sieht noch, dass er sich an Schnauze und Auge mit einer Eisenstange verletzt hat. Außerdem wurde er als neunwöchiger Welpe gebissen. Deswegen ist er auch manchmal ein wenig ängstlich, verliert aber nie sein gutes Benehmen und liebt vor allem Kinder. „Manieren sind schon wichtig im Leben."

Si Akhiro était un humain... il serait certainement un gentleman, discret et aimable. Car la vie n'a pas toujours été tendre avec lui. À y regarder de plus près, on voit qu'il a été blessé par une barre de fer au museau et à l'œil et puis mordu à l'âge de neuf semaines. Pas étonnant qu'il soit parfois un peu craintif. Cela dit, aucune raison pour lui de changer quoi que ce soit. Il adore particulièrement les enfants. « Les bonnes manières sont quelque chose d'important dans la vie. »

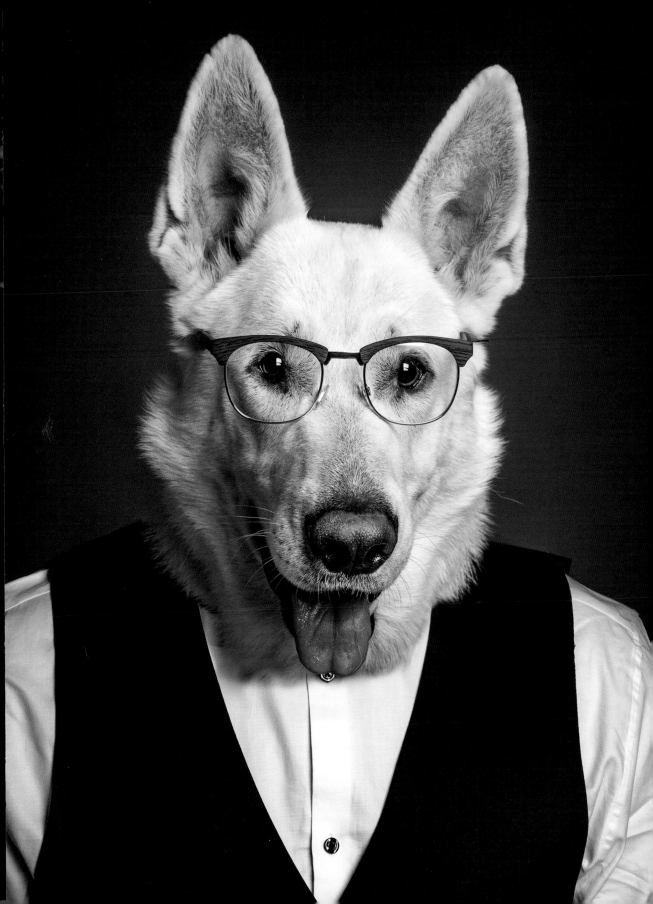

ANGIE

If Angie were human... she'd be a ship's captain. The female Australian Shepherd loves water more than anything. She dives into even the smallest puddles, so she'd clearly have to have a job involving water in her human form. But because she's also a sensitive, loyal, and reliable partner to her owners, we promoted her from deckhand to captain. "Ahoy, and cast off!"

Wäre Angie ein Mensch... wäre sie sicher Kapitänin. Die Australian-Shepherd-Hündin liebt Wasser über alles. Wo auch nur eine Pfütze ist, muss sie rein. Dass sie als Mensch also irgendetwas mit Wasser zu tun hätte, steht fest. Aber weil sie auch ein sensibler, treuer und zuverlässiger Partner für ihre Besitzer ist, haben wir sie von der Matrosin zur Kapitänin befördert. „Ahoi und Leinen los!"

Si Angie était un humain... elle serait certainement capitaine au long cours. Ce berger australien aime l'eau par-dessus tout. Une malheureuse flaque et elle y saute à pattes jointes. Comme humain, sa vie aurait sûrement un rapport avec l'eau. Pour autant, c'est aussi un partenaire sensible, fidèle et fiable pour ses propriétaires. C'est pourquoi notre matelot a été promu capitaine. « Larguez les amarres! »

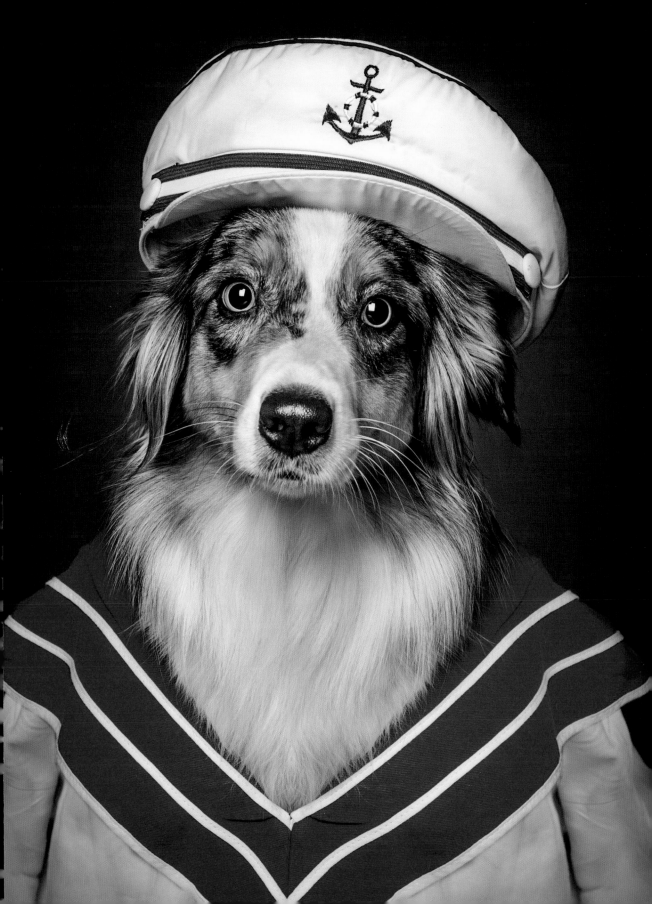

ARES

If Ares were human... he'd be a garbage man. Or maybe a happy dumpster diver. After all, the male Rottweiler is already like this as a dog. His owners look away for one second, and suddenly, there Ares is with some bit of rubbish in his mouth. "Oh, yum, moldy old cheese sandwich – down the hatch!"

Wäre Ares ein Mensch... wäre er bei der Müllabfuhr. Oder vielleicht ein glücklicher Müllsammler. Das ist der Rottweiler-Rüde nämlich schon als Hund. Seine Besitzer können gar nicht so schnell hinschauen, wie er wieder irgendeinen Unrat anschleppt. „Oh lecker, altes Käsebrot – muss ich sofort aufsaugen."

Si Ares était un humain... il serait éboueur. Ou bien un heureux collecteur d'ordures. C'est déjà ce qu'est le rottweiler comme chien. Ses propriétaires n'ont pas le temps de dire ouf qu'il a déjà rapporté n'importe quel déchet. « Oh super, une vieille tartine de fromage – à mettre tout de suite de côté. »

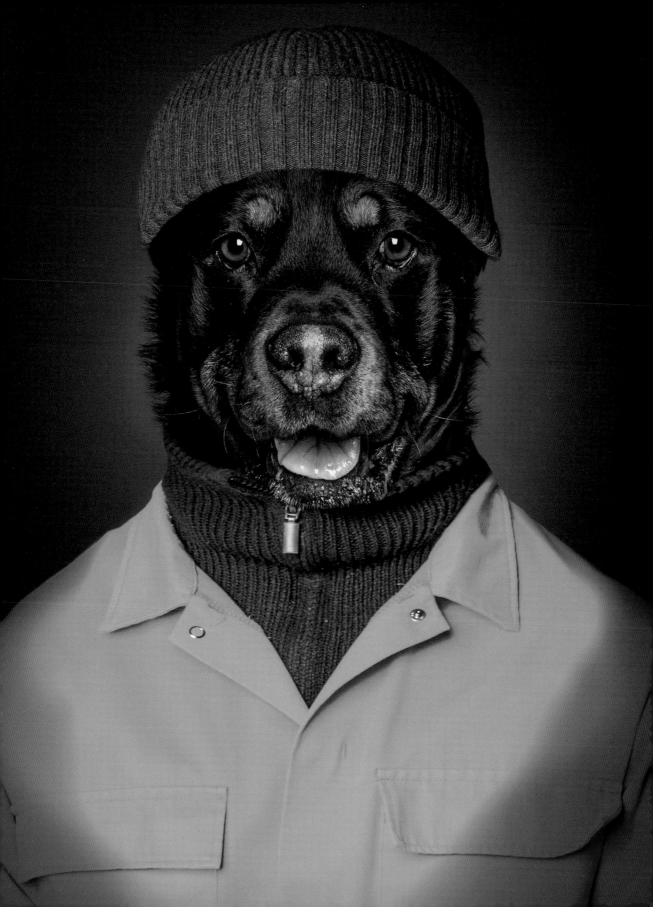

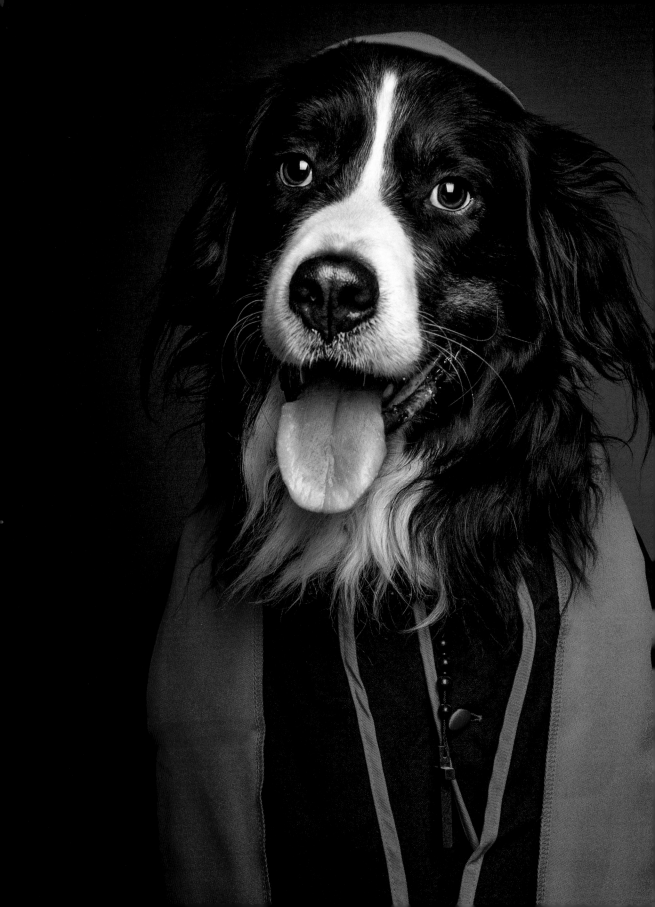

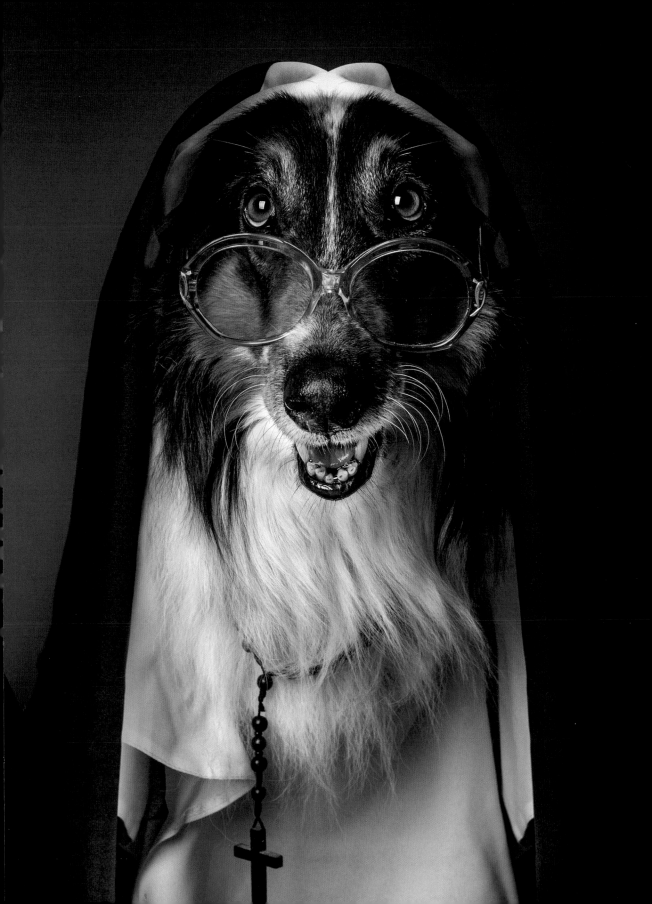

BALOU & PEGGY

Previous page

If Balou and Peggy were people... they would make a wonderful "pair" as a nun and pastor. The Bernese Mountain Dog mixes are so well-behaved and friendly and modest that I immediately thought of the church when I read about them. After all, priests and nuns are modest, follow the rules, and love everyone... "Amen!"

Wären Balou und Peggy Menschen... dachte ich mir, dass sie ein wunderbares „Paar" aus Nonne und Pastor abgeben würden. Die beiden Berner-Sennen-Mixe sind so brav und freundlich und bescheiden, dass mir bei ihrer Beschreibung sofort irgendetwas mit Kirche einfiel. Denn Priester und Nonnen sind schließlich auch bescheiden, halten sich an Vorschriften und lieben alle Menschen... „Amen!"

Si Balou et Peggy étaient des humains... j'ai pensé qu'ils formeraient un très joli « couple » bonne sœur et curé. Ces deux bouviers bernois mâtinés sont des modèles de sagesse, de gentillesse et de modestie. Je n'ai pas pu m'empêcher de penser à quelque chose en rapport avec l'Église. Car les prêtres et les religieuses sont tout aussi modestes, respectent les consignes et prêchent l'amour d'autrui... « Amen ! »

BLUE & BALIN

Next page

If Blue and Balin were human... they'd be an adorable Bavarian husband and wife. Anyone who sees the two Boston Terriers together notices immediately that she is clearly the boss. Her husband Balin is unruffled by her commandeering: "Balin – you come here immediately, the photographer is waiting for us." "Whatever you want, my darling Blue."

Wären Blue und Balin Menschen... wären sie ein wunderbares bayerisches Bauernpaar. Wer die beiden Boston Terrier erlebt, merkt sofort: Sie ist ganz klar die Chefin. Ihr Mann Balin trägt ihre Kommandos mit Gelassenheit: „Balin, her gehst, jetzt mach ma a Foto!" – „Wennst moanst Spazl... "

Si Blue et Balin étaient des humains... ils formeraient un pittoresque couple de Bavarois. Quand on connaît ces deux terriers de Boston, on n'est pas long à remarquer : c'est elle qui porte la culotte. Son homme Balin obéit aux ordres avec flegme : « Balin, viens par-là, on se fait tirer le portrait ! » – « Ben, si tu veux mon chou... »

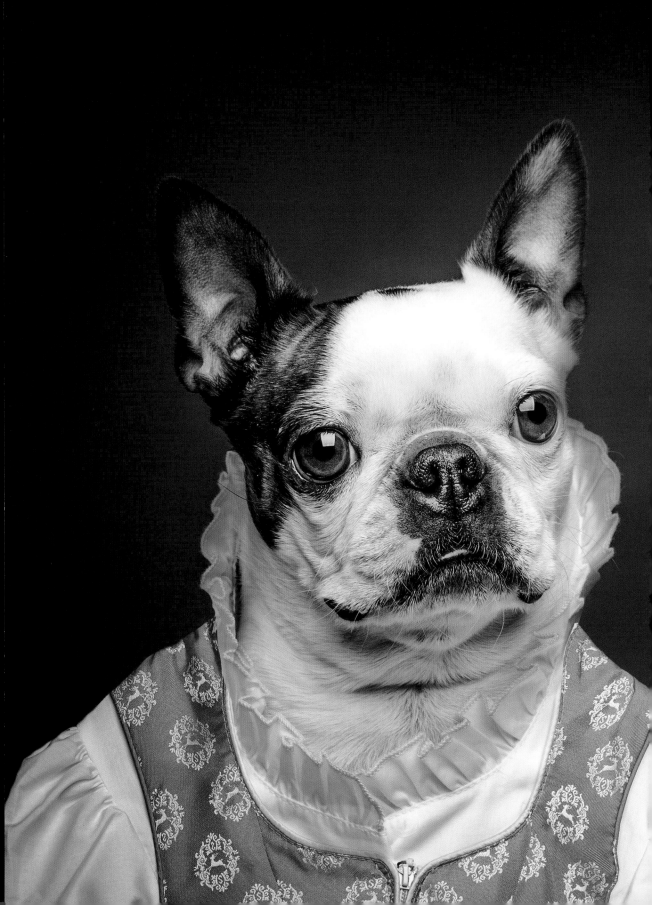

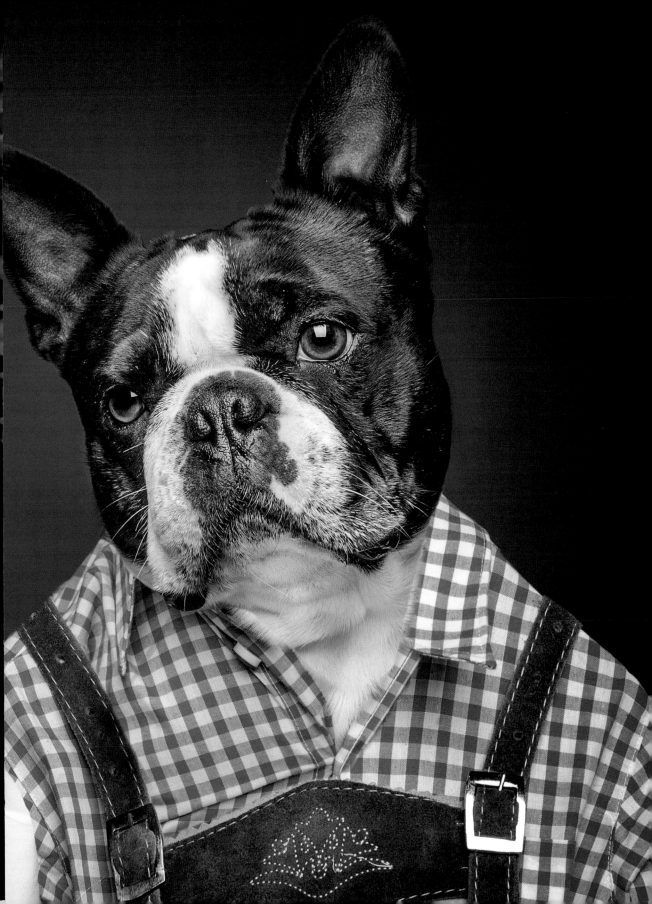

BELLA

If Bella were a person... she'd just be a little kid. The Border Collie mix was only eight months old, with all the playfulness you'd expect, when we took this photo. So I decided to give her a sailor suit and a sturdy jacket. "Come on, let's go play!"

Wäre Bella ein Mensch... wäre sie einfach noch ein kleines Kind. Die Hündin, ein Border-Collie-Mix war beim Shooting auch tatsächlich erst acht Monate alt – und entsprechend verspielt. Daher fiel die Entscheidung auf Matrosenpulli und strapazierfähige Jacke. „Los, wir gehen jetzt spielen!"

Si Bella était un humain... elle serait simplement encore un jeune enfant. Cette chienne croisée border collie n'avait effectivement que huit mois lors du shooting – et s'est montrée très enjouée. La décision de lui enfiler un pull marin et une veste « qui ne craint rien » a été prise tout naturellement. « C'est bon ? J'ai le droit d'aller jouer ? »

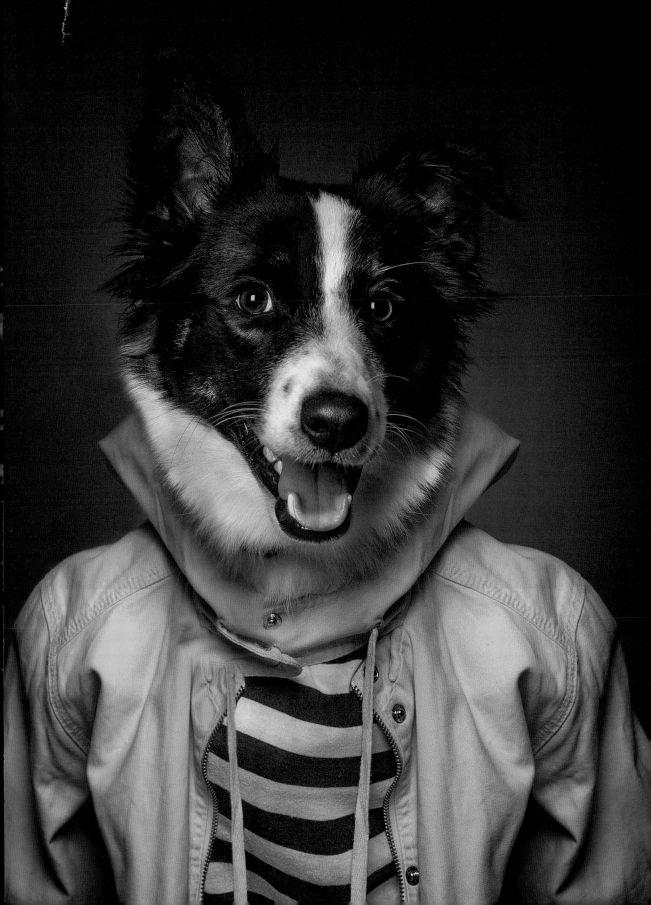

BENNI

If Benni were human... he'd be a model. The Sheltie knows just how handsome he is, and even his gait is a little snooty, but he wouldn't hurt a fly. He won't even defend himself if other dogs steal his stick – he doesn't want to lower himself to their level. "Beauty is also a question of style!"

Wäre Benni ein Mensch... wäre er ein kleiner Beau. Der Sheltie-Rüde weiß genau, wie hübsch er ist, und sein Gang wirkt auch ein bisschen hochnäsig. Dabei kann er keiner Fliege etwas zuleide tun. Nicht mal, wenn ihm ein anderer sein Stöckchen wegnimmt, wehrt er sich – wahrscheinlich will er sich gar nicht erst auf dieses Niveau einlassen. „Schönheit ist auch Stil-Sache!"

Si Benni était un humain... il serait un jeune beau. Ce berger des Shetland sait pertinemment combien il est distingué. Jusqu'à sa démarche qui semble quelque peu arrogante. Pourtant, ce n'est pas lui qui ferait quoi que ce soit à une mouche. Il ne se défend même pas quand on lui vole son bâton – sans doute qu'il ne veut pas s'abaisser à ce niveau. « La beauté est aussi une question de style ! »

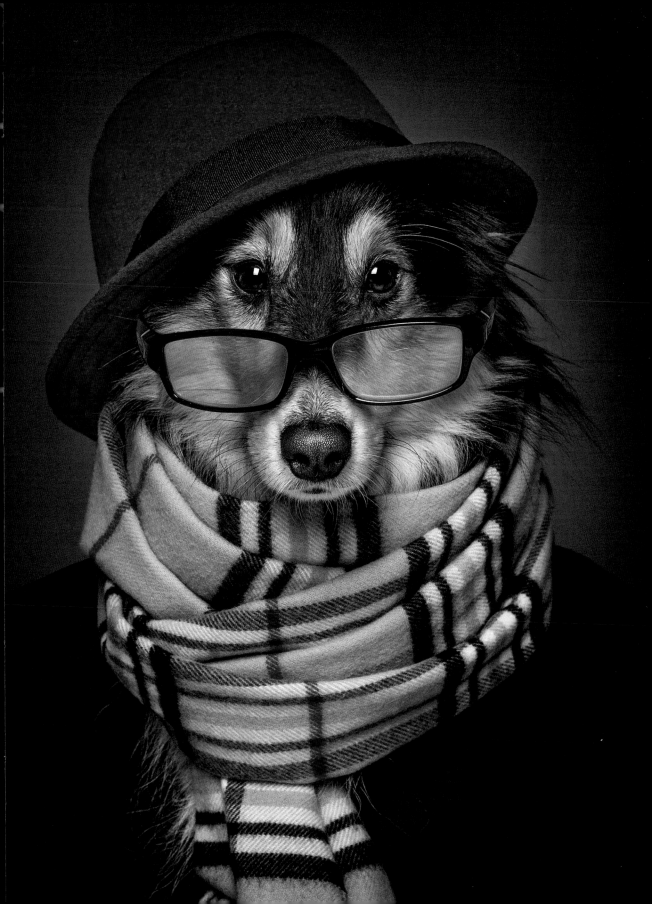

BEPPO VON DER GEISTERMÜHLE

If Beppo were human... he'd definitely be a cool hip-hopper. Beppo may be an elegant purebred Giant Schnauzer, but he is also a little troublemaker who likes to pick fights with other males. He's a cool daredevil and provocateur. "Totally rad, man!"

Wäre Beppo ein Mensch... wäre er bestimmt ein cooler Hip-Hopper. Beppo ist zwar ein edler reinrassiger Riesenschnauzer aber auch ein kleiner Stänkerer, der sich vor allem gerne mit anderen Rüden anlegt. Ein cooler Draufgänger und Provozierer. „Voll krass, ey!"

Si Beppo était un humain... il serait certainement super hyper cool dans la catégorie Hip-Hopper. Beppo est un schnauzer géant de pure race, mais aussi un râleur de la plus belle espèce qui adore se frotter aux autres mâles. Un fonceur chill un brin provocateur. « Trop cool, mec ! »

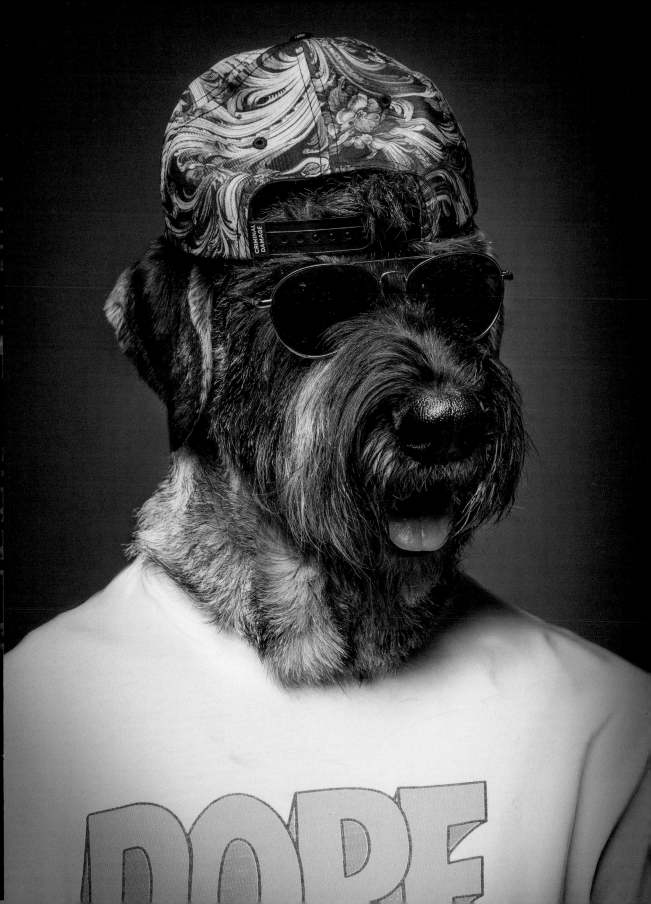

BONSAI

If Bonsai were human... he would be quite the over-achiever. Vizsla mix Bonsai always wants to be the best student in his obedience class and works hard to learn everything quickly and perfectly. "Teacher, teacher, pick me, I know the answer!" Fortunately, the other dogs don't have a problem with it – they play with him anyway.

Wäre Bonsai ein Mensch... wäre er ein richtiger kleiner Streber. Der Vizsla-Mischling Bonsai will in der Hundeschule unbedingt immer der Beste sein und strengt sich daher an, alles ganz schnell und perfekt zu lernen. „Herr Lehrer, Herr Lehrer, ich weiß was!" Gut, dass das unter Hunden gar kein Problem ist – die anderen spielen trotzdem mit ihm.

Si Bonsai était un humain... il serait un vrai petit fayot. Ce croisé Braque hongrois veut toujours être le meilleur à l'école de chiens et s'efforce d'apprendre tout le plus vite et le mieux possible. « Monsieur, Monsieur, je sais ! » Heureusement que pour les chiens, tout ça n'est pas un problème – ses camarades jouent quand même avec lui.

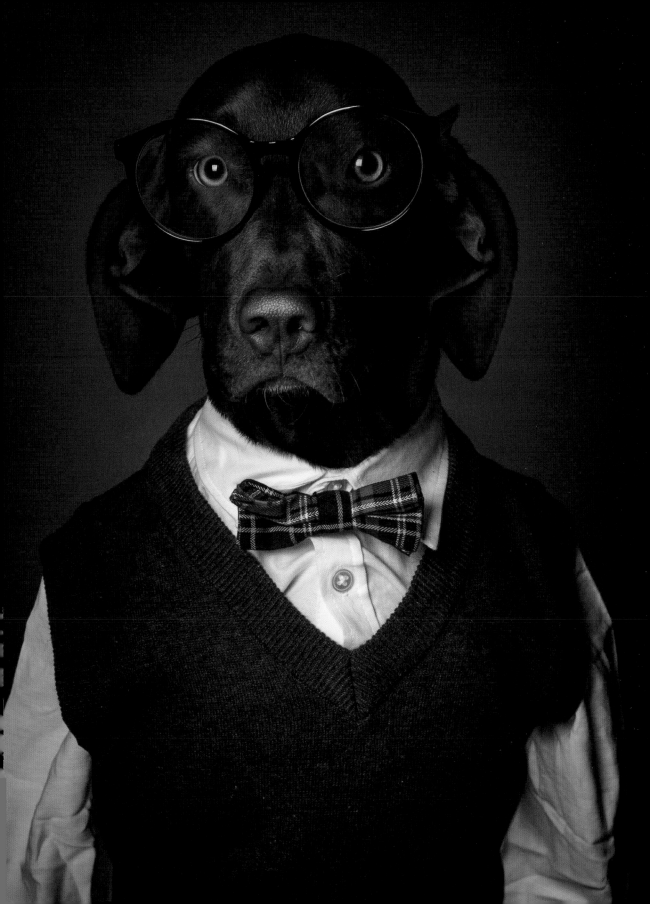

BUDDY

If Buddy were human... he would just be happy to be living in a safe home. The picture touches on his history because it is part of what makes him special now. Today, Buddy is simply sweet and well-behaved – and happy that he can live in peace with his owner. But it was a long road – all the way from the Philippines, where he basically came to his mistress as a stray. "I'll never need these stupid flowers again!"

Wäre Buddy ein Mensch... wäre er einfach nur glücklich, in einem sicheren Heim zu leben. Das Bild greift seine Geschichte auf, weil sie zu dem gehört, was ihn heute ausmacht. Denn heute ist Buddy einfach nur brav und lieb – und froh, dass er jetzt in Frieden bei seiner Besitzerin leben kann. Doch bis dahin war es ein langer Weg – von den Philippinen, wo er seinem Frauchen quasi zugelaufen ist. „Die blöden Blumen brauch ich nie wieder!"

Si Buddy était un humain... il serait simplement heureux de vivre en sécurité chez lui. La photo se réfère à son histoire parce qu'elle fait partie de ce qu'il est aujourd'hui : simplement sage et gentil – et content de pouvoir vivre en paix chez sa propriétaire. Mais avant cela, sa vie a été un parcours semé d'embûches – depuis les Philippines, où il a pratiquement adopté sa maîtresse. « Ridicules ces fleurs, mais c'est juste pour une fois ! »

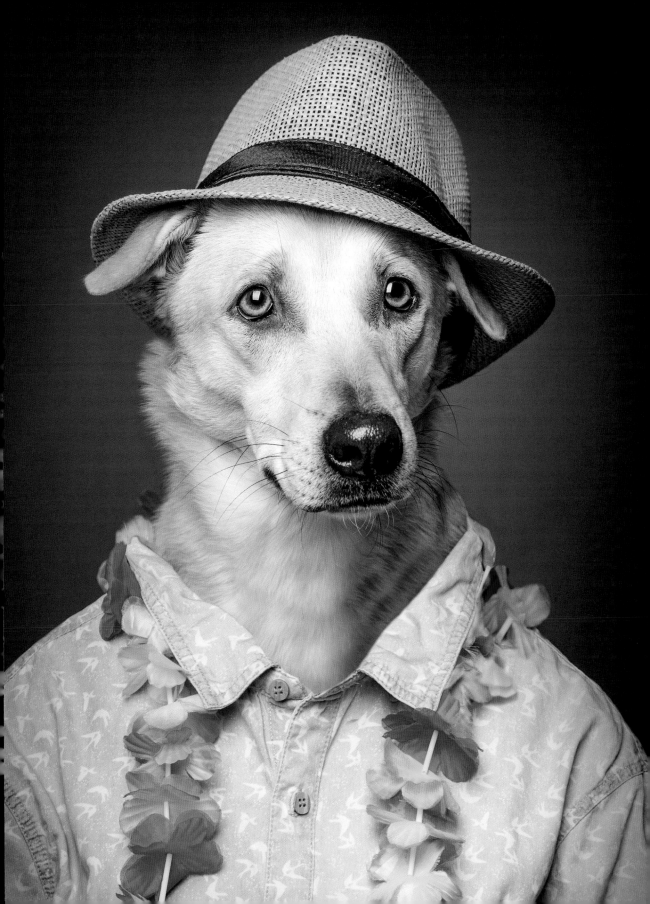

CAWA

If Cawa were human... he'd be a leftover hippie from the 60s. According to his owner, the male Siberian Husky is a little wacky and just loves everyone and everything – total flower power! Everyone is great and everything is easy – so it was actually perfect that the flower wreath on his head slipped to the side during our photoshoot. "Peace and love!"

Wäre Cawa ein Mensch... wäre er ein übriggebliebener Hippie aus den 60er-Jahren. Der Siberian-Husky-Rüde ist laut seiner Besitzerin ein bisschen durchgeknallt und liebt einfach alle und alles – absolute Flower-Power. Jeder ist toll und alles ist easy – dass das Blumenband beim Shooting auf die Seite gerutscht ist, hat dann eigentlich perfekt gepasst. „Peace and Love!"

Si Cawa était un humain... il serait un hippie nostalgique des années 1960. À en croire sa propriétaire, ce husky sibérien un peu allumé aime simplement tout et tout le monde – un hymne au Flower-Power. Tout le monde il est gentil et cool Raoul – finalement, le collier de fleurs glissé sur le côté pendant le shooting est tout à fait dans l'ambiance. « Peace and love ».

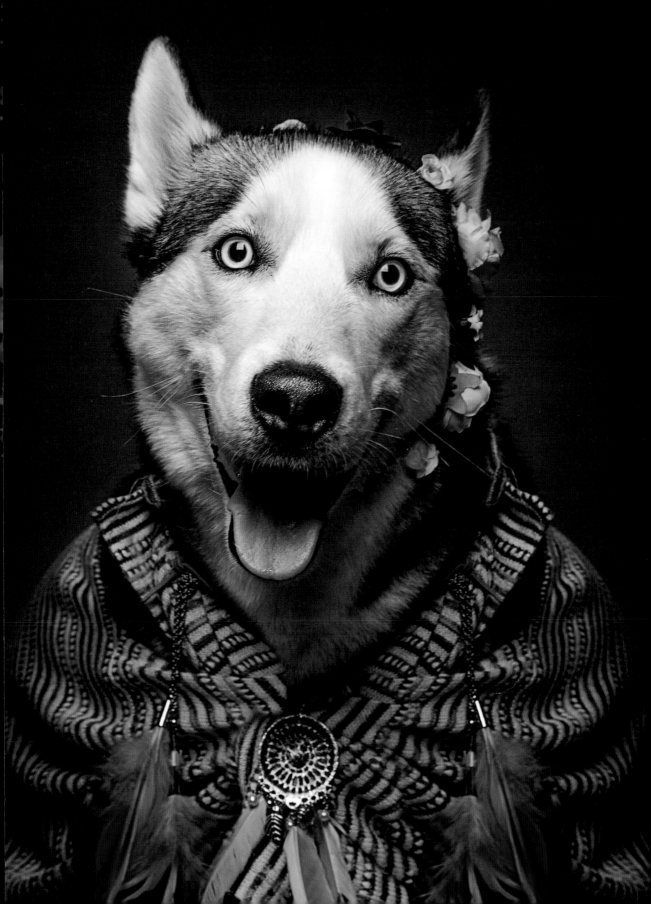

FRIEDA
(CECILIE MOUNTAINVIEWS BULL)

If Cecilie were human... she'd be a newborn baby with an old soul. The female Old English Bulldog, whose call name is simply "Frieda," was only twelve weeks old when photographed, and I actually wanted to show her as a cuddly but slightly diffident baby. But somehow, with her tiny wrinkly face, she could be a very sweet (but crotchety) granny, too. "Gracious, it certainly is cold outside!"

Wäre Cecilie ein Mensch... wäre sie ein kleines Baby mit einer alten Seele. Die Olde-English-Bulldoggen-Lady, die im wahren Leben einfach „Frieda" heißt, war beim Shooting gerade mal zwölf Wochen alt und eigentlich wollte ich sie als knuddeliges, ein bisschen verfrorenes Baby zeigen. Aber irgendwie könnte sie mit ihrem kleinen Knautschgesicht auch eine ganz liebe (auch verfrorene) Omi sein. „Manno, ist das kalt draußen!"

Si Cecilie était un humain... elle serait un tout petit bébé avec une vieille âme. Cette chienne de race vieux bouledogue anglais qui, en réalité, se nomme « Frieda », n'avait que douze semaines au moment du shooting. Au départ, je voulais la présenter comme un mignon bébé un peu frileux. Mais avec son petit visage fripé, elle peut tout aussi bien passer pour une adorable mamie (tout aussi frileuse). « C'est qu'il ne fait pas chaud dehors ! »

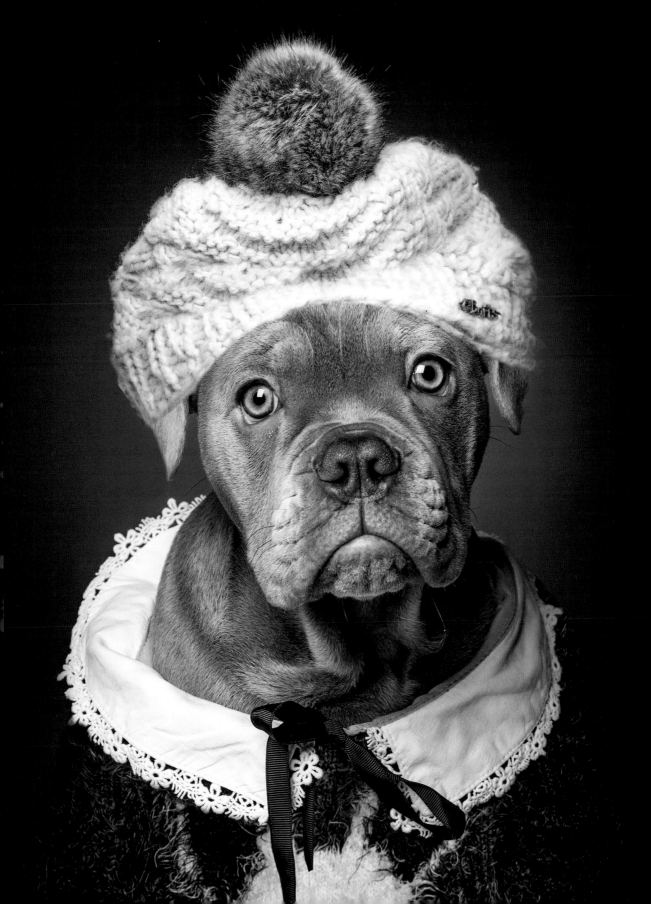

CHILI

If Chili were human... she'd be the perfect maid. Chili is a Border Collie/Jack Russell mix with inexhaustible energy. Although she went on a two-hour walk before her photoshoot, she was still bouncing off the walls in the studio. But when she trains with her owners, she always works very quickly, is a little whirlwind, and wants to do everything perfectly. "All finished – what next?"

Wäre Chili ein Mensch... wäre sie das perfekte Dienstmädchen. Chili ist ein Border-Collie-Jack-Russell-Mischling mit unerschöpflicher Energie. Obwohl sie vor dem Shooting zwei Stunden Gassi war, hat sie vor der Kamera schon wieder voll aufgedreht. Aber beim Training mit ihren Besitzern arbeitet sie immer sehr schnell, ist ein kleiner Wusler und möchte alles perfekt machen. „Alles erledigt – und was kommt als nächstes?"

Si Chili était un humain... elle serait une domestique très zélée. Chili est un border collie croisé Jack Russell doté d'une énergie féroce. Avant le shooting, elle avait fait une balade de deux heures, mais à peine devant la caméra, elle avait manifestement déjà des fourmis dans les pattes. Quand elle s'entraîne avec ses maîtres, elle travaille très vite, ne tient pas en place et veut tout faire parfaitement. « C'est réglé – et maintenant, qu'est-ce qu'on fait ? »

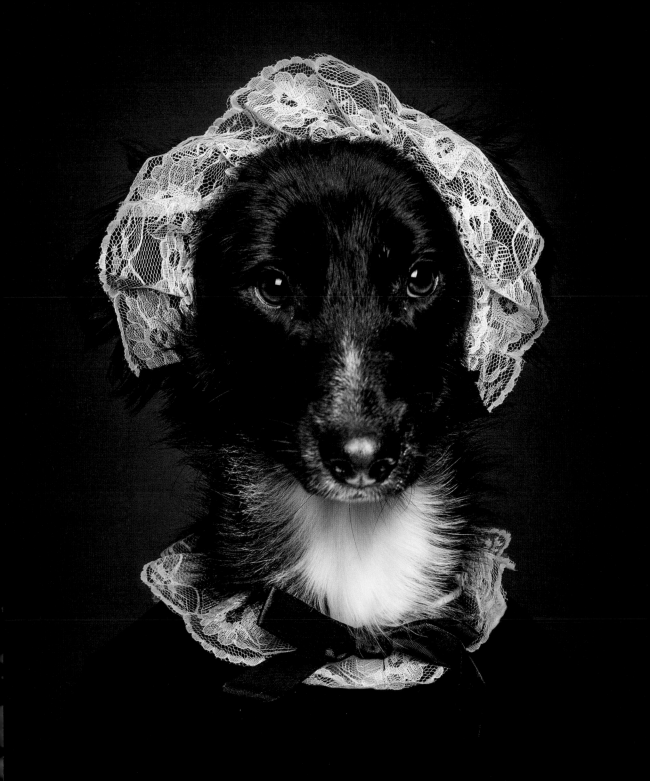

MILA
(CRAGGANMORE'S GORDANA)

If Mila were human... she could be the sister of Bonsai (on page 30/31). She is a nerd as well. She was just five months old when we took this photograph and could already do all the tricks she learned at puppy school much better than her classmates. And when we put her glasses on, she immediately went totally still and didn't move a muscle, even though a fly was buzzing around her head! "I'm just the sweetest girl ever, aren't I?"

Wäre Mila ein Mensch... könnte sie die Schwester von Bonsai (auf Seite 30/31) sein. Auch sie ist eine kleine Streberin. Bei den Aufnahmen war sie gerade erst fünf Monate alt und konnte schon alle Tricks aus der Hunde-schule viel besser als ihre Mitschüler. Und als wir ihr die Brille aufgesetzt haben, ist sie sofort ganz ruhig geworden und hat den Kopf nicht mehr bewegt – obwohl ihr sogar eine Fliege um den Kopf geflogen ist! „Ich bin eben die Liebste überhaupt, gell!"

Si Mila était un humain... elle pourrait être la sœur de Bonsai (à la page 30/31). Elle aussi est une petite fayote. Pendant les photos, elle n'avait que cinq mois et connaissait déjà toutes les ficelles de l'école de chiens bien mieux que ses camarades. Lorsque nous lui avons mis les lunettes, elle s'est tout de suite calmée et n'a plus bougé la tête – et ça, même quand une mouche lui a tourné autour ! « Je suis la plus mignonne, c'est tout ! »

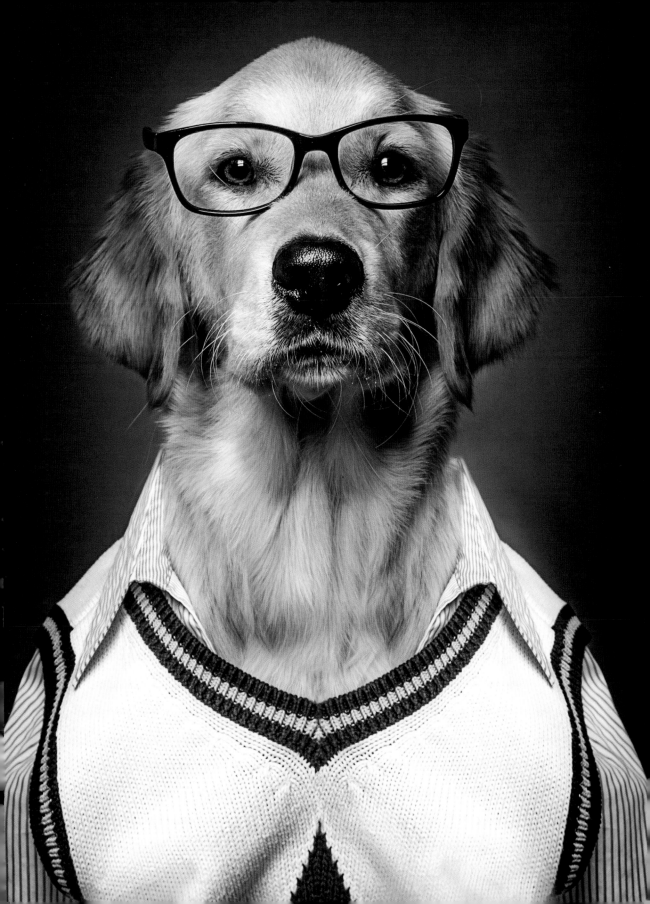

CRAZY

If Crazy were human... she'd be a cool hipster. The Miniature Bull Terrier mix is super sporty and agile, but she can also be very chill and relaxed. But when she gets together with her posse, it's party time, so we had to add a little color to her outfit. "Hey, what's goin' on?"

Wäre Crazy ein Mensch... wäre sie ein cooler Hipster. Die Mini-Bullterrier-Mix-Hündin ist super sportlich und agil, kann aber auch ganz gechillt und gelassen sein. Aber im Rudel mit den anderen wird Party gemacht. Daher musste schon ein bisschen Farbe ins Outfit. „Hey, was geht ab?"

Si Crazy était un humain... elle serait un hipster très cool. La chienne croisée mini bull terrier est super sportive et agile, mais peut aussi se montrer chill et parfaitement relax. Cela dit, dans la clique, elle est toujours prête à faire la fête. Il lui fallait vraiment un peu de couleur dans sa tenue. « Eh, qu'est-ce qui se passe ici ? »

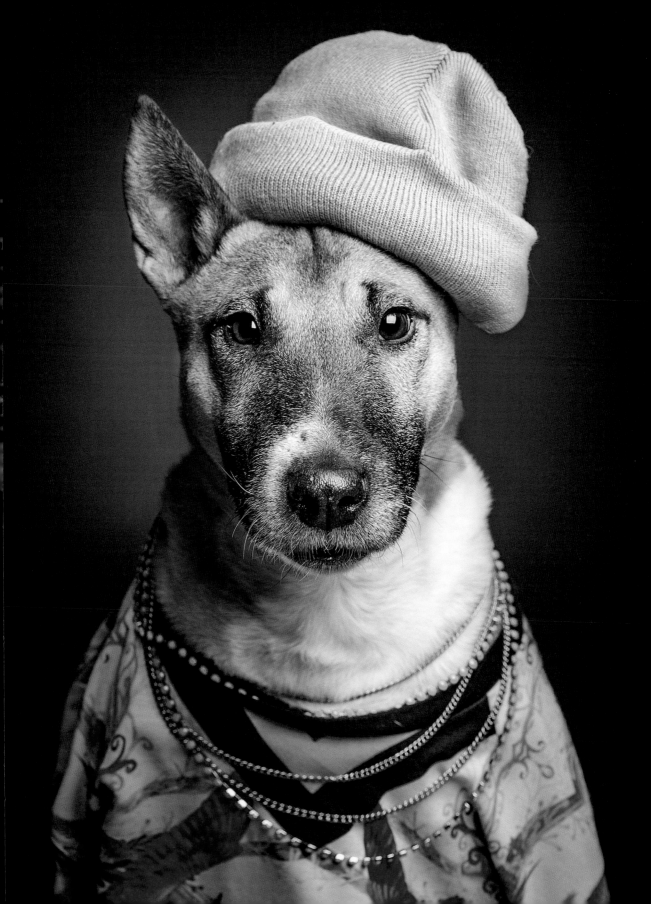

DIEGO

If Diego were human... he could be an older lord of the manor. The Labrador/Brittany mix doesn't see or hear very well any more, but he still has the air of a true gentleman despite his advanced age (he is eleven). I think it's even clearer when you look at his portrait in the appendix. You just can't deny nobility. "What did you say, Madam?"

Wäre Diego ein Mensch... könnte er ein etwas älterer Lord sein. Der Labrador-Bretone hört und sieht schon ziemlich schlecht. Aber trotz seiner fortgeschrittenen Jahre (er ist elf) wirkt er immer noch wie ein feiner Herr. Ich finde, das sieht man besonders bei seinem natürlichen Bild im Anhang. Adel lässt sich eben nicht verleugnen. „What did you say, Madam?"

Si Diego était un humain... il pourrait être un lord d'un certain âge. Cet épagneul breton n'entend et ne voit plus très bien. Mais malgré le poids des années (onze ans), il a toujours l'air aussi distingué. Je trouve que son élégance apparaît très bien sur la photo au naturel en annexe. On ne renie pas ses origines nobles. « What did you say, Madam ? »

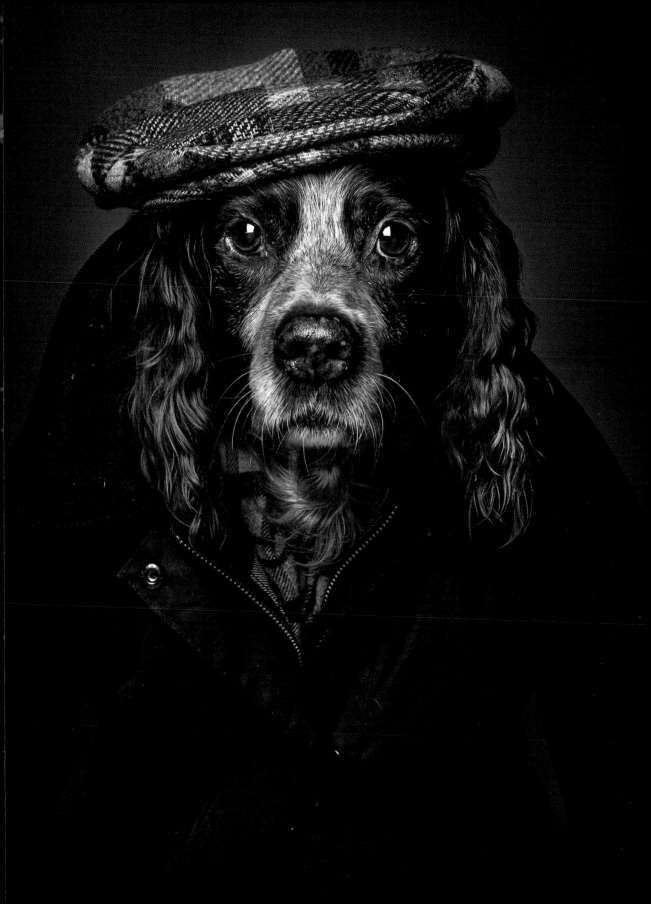

DJANGO

If Django were human... he would probably be thrilled to be a chimney sweep. He is only too happy to get himself dirty. It's a good thing that his nose is already flecked with black and his eyes are naturally ringed in black as well, so a little more soot isn't really noticeable. "Pet me for good luck!"

Wäre Django ein Mensch... wäre er wahrscheinlich am liebsten Schornsteinfeger. Denn er macht sich einfach zu gerne schmutzig. Wie gut, dass seine Nase ohnehin schon schwarz gefleckt ist und auch seine Augen natürlich schwarze Ränder haben, da fällt ein bisschen Ruß gar nicht mehr auf: „Streichelt mich – ich bringe Glück."

Si Django était un humain... il aimerait certainement être ramoneur. Car reconnaissons les faits : il adore se salir dans toutes les situations. Ça tombe bien que son nez soit à l'état naturel déjà moucheté et ses yeux naturellement bordés de noir. Un peu de suie par là-dessus ne se remarquera même pas : « Caressez-moi, je porte bonheur. »

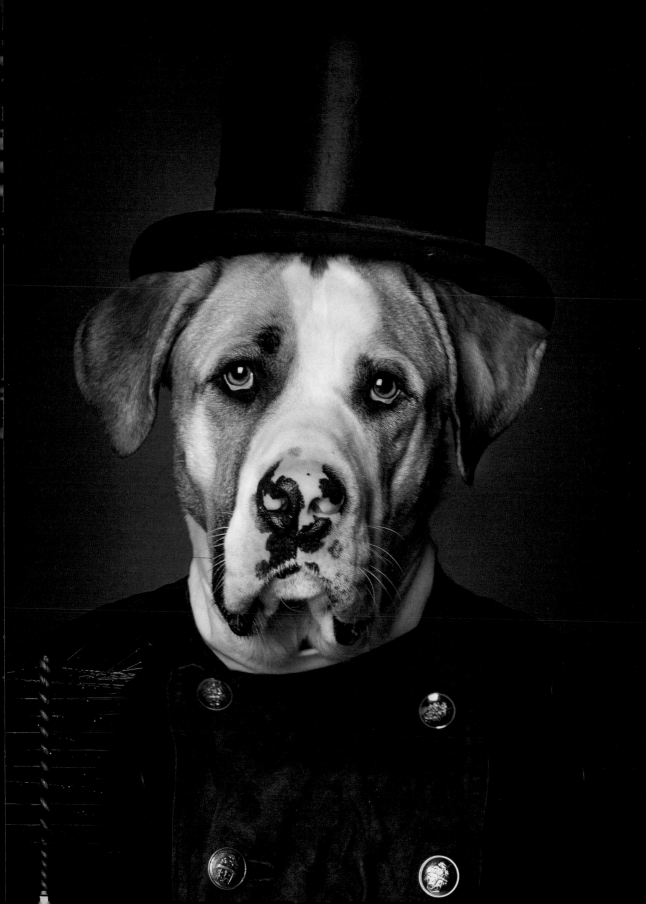

DONATELLA VOM WONNEBERG

If Donatella were human... she'd be a hunter, of course. She's a Small Munsterlander Pointer, is an active hunting dog, and is unstoppable when pursuing game. The only thing that helps is the hunting whistle she's wearing around her neck in this picture. "When you blow it, she'll come – usually," say her owners. "Tally ho!"

Wäre Donatella ein Mensch... wäre sie natürlich eine Jägerin. Sie gehört zur Rasse der kleinen Münsterländer, wird auch als Jagdhund geführt und ist im Jagdeinsatz kaum zu bremsen. Einziges Hilfsmittel: die Jagdpfeife, die sie hier auf dem Bild um den Hals trägt. „Wenn man mit der pfeift, kommt sie – normalerweise", versichern ihre Besitzer. „Halali!"

Si Donatella était un humain... elle serait bien évidemment chasseur. Nous avons là la race petite Münsterländer, un chien de chasse typique. Le fait est qu'il est difficile de la freiner dans son élan chasseur. Seul moyen : le sifflet de chasse qu'elle porte autour du cou sur la photo. « Un coup de sifflet et elle rapplique – du moins normalement », assurent ses propriétaires. « Hallali ! »

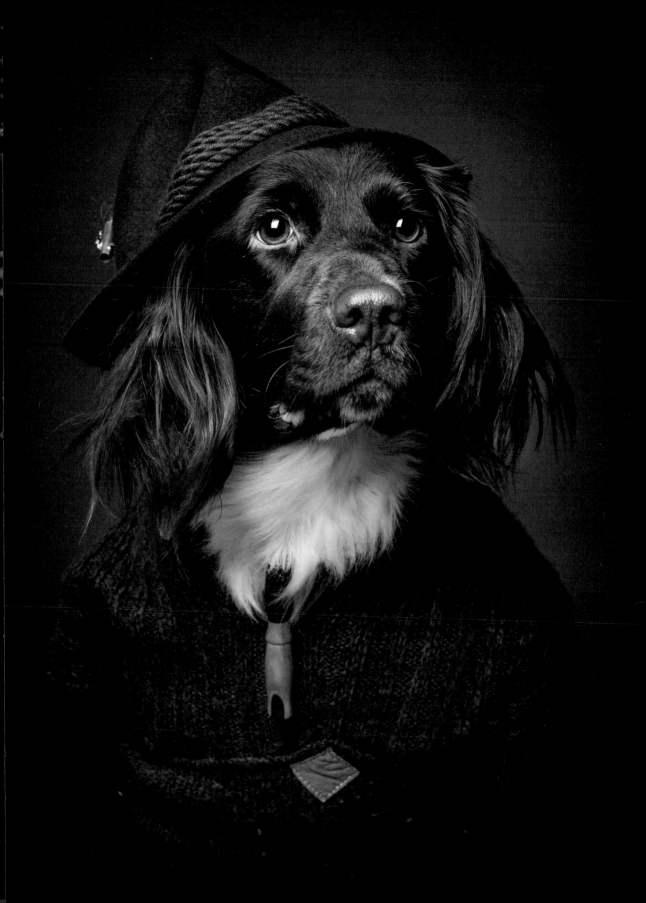

ELLA

If Ella were human... she'd probably be the world's biggest Bob Marley fan. She is a totally relaxed German Hunting Terrier mix, friendly to just about everyone. But that look in her eyes! Her owner has been asked several times whether Ella is on any drugs – which she of course is not. Ella is just a little reggae mama.

Wäre Ella ein Mensch... wäre sie wahrscheinlich der größte Bob-Marley-Fan. Sie ist ein total entspannter Deutscher-Jagdterrier-Mix, freundlich zu fast jedem. Aber dieser Blick! Ihre Besitzerin wurde tatsächlich schon mehrmals gefragt, ob Ella irgendwelche Drogen genommen habe – was natürlich nicht der Fall ist. Ella ist einfach eine kleine Reggae-Braut.

Si Ella était un humain... elle serait probablement la plus grande fan de Bob Marley. C'est un terrier de chasse allemand mâtiné très relax et agréable avec presque tout le monde. Mais ce regard ! On a effectivement souvent demandé à sa propriétaire si elle était droguée – ce qui n'est évidemment pas le cas. C'est juste une petite minette fan de reggae.

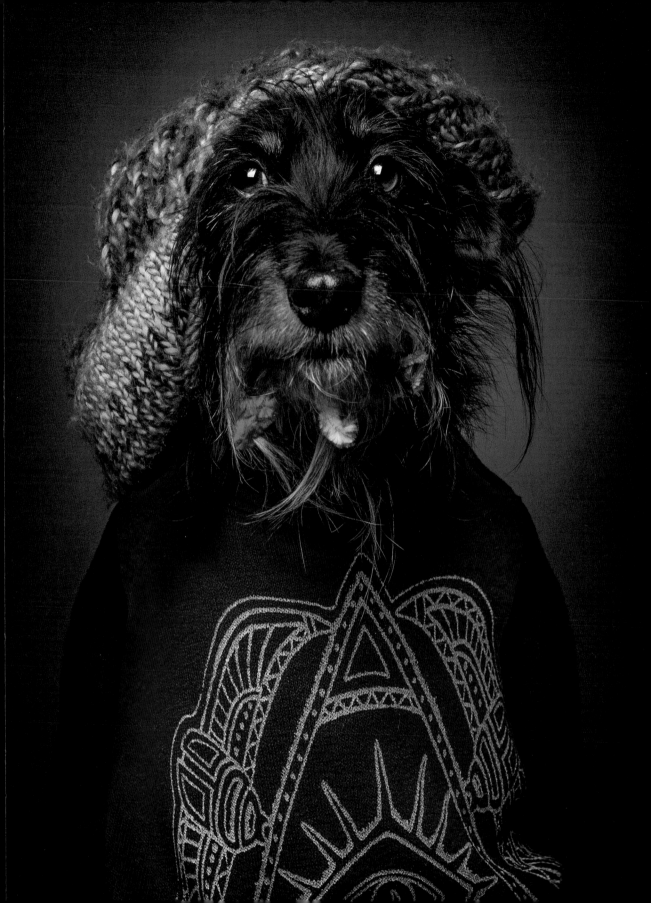

NINO
(ELNIN'O THE SPIRIT OF ARATANKA)

If Nino were human... he'd probably be a medical school professor. As a Standard Poodle, he is pretty large and impressive – and he has a pretty high opinion of himself as someone special, too. Which he is, though not because of his looks. His mistress is diabetic, and even though Nino is just eight months old and not trained as an alert dog, he always signals immediately when her blood sugar is low. "Ladies and gentleman, allow me to provide a detailed explanation."

Wäre Nino ein Mensch... wäre er wahrscheinlich ein Universitätsprofessor der medizinischen Fakultät. Als Königspudel ist er ziemlich groß und beeindruckend – und ein bisschen hält er sich auch selbst für etwas Besonderes. Was er tatsächlich ist, allerdings nicht wegen seines Äußeren. Sein Frauchen leidet unter Diabetes und – obwohl Nino erst acht Monate alt ist und nicht darauf trainiert wurde – zeigt er bei ihr immer sofort den Unterzucker an. „Meine Herrschaften, lassen Sie sich das einmal im Detail erklären."

Si Nino était un humain... il serait probablement professeur d'université à la faculté de médecine. Caniche royal, il est de bonne taille et assez impressionnant – et puis, disons-le, il ne se prend pas pour n'importe qui. Il a raison dans un sens, mais pas pour son physique. Sa maîtresse souffre de diabète et – bien que Nino n'ait que huit mois et n'ait pas été entraîné pour – il est capable de lui signaler son hyperglycémie. « Mesdames et Messieurs, laissez-moi vous expliquer les détails. »

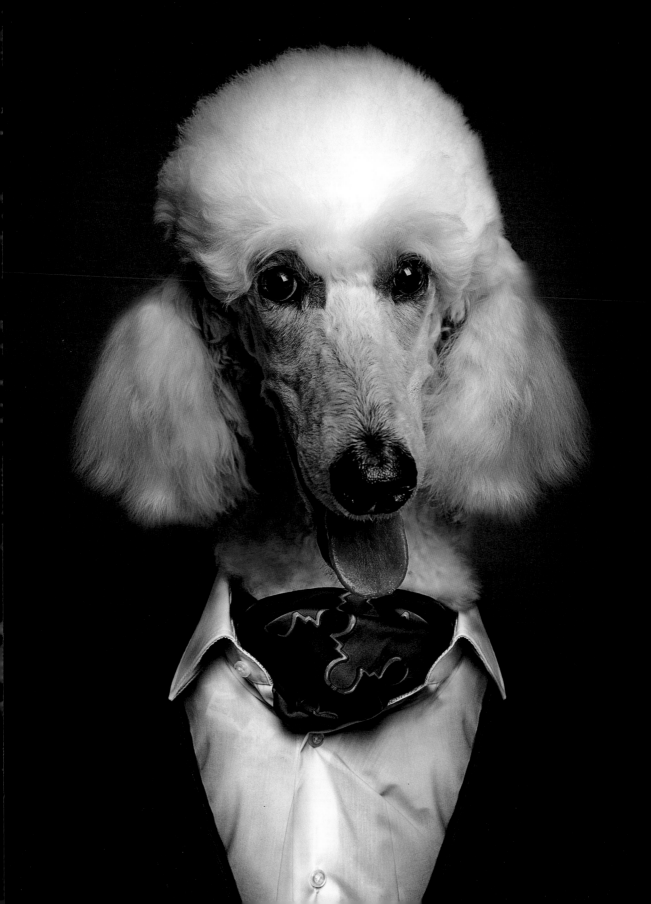

EMMI

If Emmi were human... she'd be an academic. The female Bearded Collie is not only a certified reading assistance dog, she is also a therapy dog. Reading assistance dog? Yes, these specially trained dogs are used to alleviate kids' fear of reading aloud. Among other benefits, they help kids learn to love reading by listening without judgment and allowing children to read at their own pace. Reading dogs are being used in more and more schools. You learn something new every day!

Wäre Emmi ein Mensch... wäre sie Akademikerin. Die Bearded-Collie-Hündin hat nicht nur einen Abschluss als Lesebegleithund, sondern ist auch Therapiehund. Lese-begleithund? Ja, diese speziell trainierten Hunde werden eingesetzt, um Kindern die Angst vor dem Vorlesen zu nehmen. Unter anderem stärken sie die Lust am Lesen, weil sie zuhören ohne zu urteilen und den kleinen Vorlesern erlauben, in ihrem eigenen Tempo zu lesen. Sie werden mittlerweile in immer mehr Schulen eingesetzt. Wieder was gelernt!

Si Emmi était un humain... elle serait une universitaire. La chienne Bearded Collie n'a pas seulement un diplôme de chien de lecture, mais est aussi chien thérapeutique. Chien de lecture ? Oui, ces chiens formés spécialement sont mobilisés pour surmonter la peur de lire à haute voix chez les enfants. Ainsi, ils encouragent le goût de la lecture chez les enfants car ils savent écouter sans juger et permettent aux petits lecteurs de lire à leur rythme. Entre-temps, ils sont de plus en plus demandés dans les écoles. On a encore appris quelque chose !

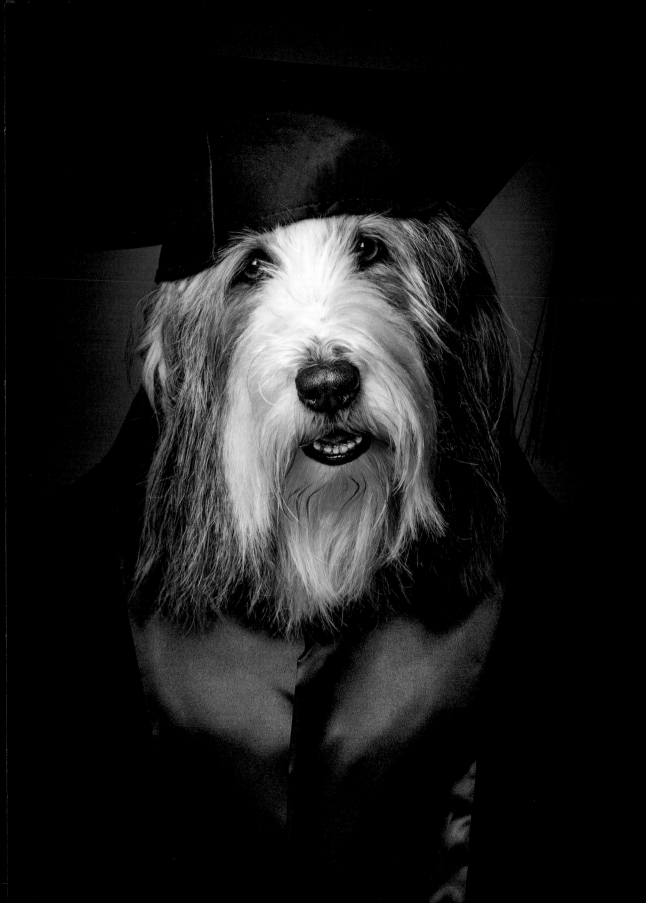

FRANZI

If Franzi were human... she might be a geisha. They come from Japan and Franzi is a Chinese Crested Dog, but both are in Asia, at least. And geisha fits her so perfectly: a geisha must be graceful, charming, well-informed and witty – Franzi can do all that in her sleep. And then her white face with her black hair – we just had to put her in a kimono. Miss Thousand Spring Blossoms.

Wäre Franzi ein Mensch... wäre sie vielleicht eine Geisha. Die kommen zwar aus Japan und Franzi ist ein Chinesischer Schopfhund, aber zumindest ist das doch beides in Asien. Und die Geisha passt so perfekt: Eine Geisha muss anmutig, charmant, gebildet und geistreich wirken – na, das schafft die kleine Franzi doch mit links. Und dann ein weißes Gesicht mit schwarzen Haaren... da musste einfach noch ein Kimono dazu kommen. Fräulein Tausend-Frühlingsblüten.

Si Franzi était un humain... elle serait peut-être une geisha. Certes, la geisha est typiquement japonaise et Franzi est un chien chinois à crête, mais enfin bon, tout cela reste en Asie. Et vraiment, on peut très bien l'imaginer en geisha : une geisha doit être gracieuse, charmante, cultivée et spirituelle – et la petite Franzi remplit magnifiquement son rôle. Et puis, ce visage blanc avec les poils noirs... il ne lui fallait plus qu'un kimono. Mademoiselle Pays du Soleil-Levant.

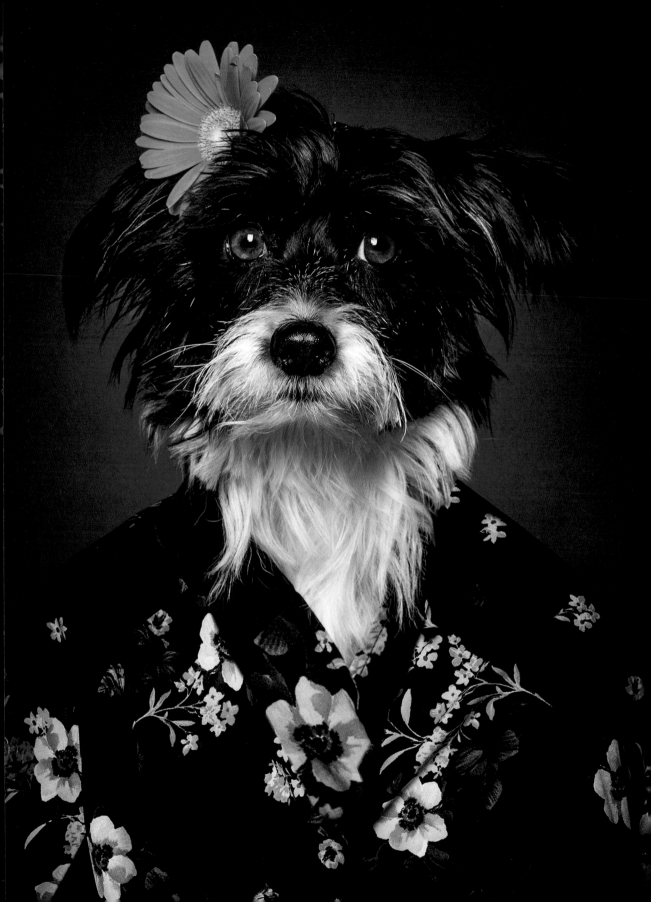

FREDDIE

If Freddie were human... he'd be a member of a street gang. Dachshund Freddie is often quite shy and fearful, but frequently turns into an overbearing macho with others. And as is so often the case with human show-offs, Freddie merely longs to be loved. Unfortunately, he has already been passed around quite a bit in his five years of life. But now he is in a truly loving home at last and can show off all he likes. Little courage – big mouth.

Wäre Freddie ein Mensch... dann wäre er Mitglied einer Straßengang. Dackel Freddie ist nämlich ziemlich schüchtern und eher ängstlich, anderen gegenüber aber gerne mal ein kleiner Macho. Und wie das auch bei menschlichen Angebern eben oft so ist: Eigentlich sehnt sich Freddie nur nach Liebe. Leider wurde er nämlich mit seinen fünf Jahren schon ziemlich viel herumgereicht. Aber nun ist er endlich bei lieben Menschen angekommen und kann schon wieder auftrumpfen. Kleiner Mut – große Klappe.

Si Freddie était un humain... il serait membre d'un gang de rue. Le teckel se montre souvent assez timide et plutôt craintif, et pourtant, il joue volontiers les machos avec les autres. Et comme c'est souvent le cas dans la catégorie frimeurs, humains ou chiens, Freddie est simplement en mal d'amour. À cinq ans seulement, il est malheureusement déjà passé entre de multiples mains. Mais maintenant, il a enfin trouvé des maîtres adorables et peut poursuivre son petit jeu. Une grande gueule avec rien derrière.

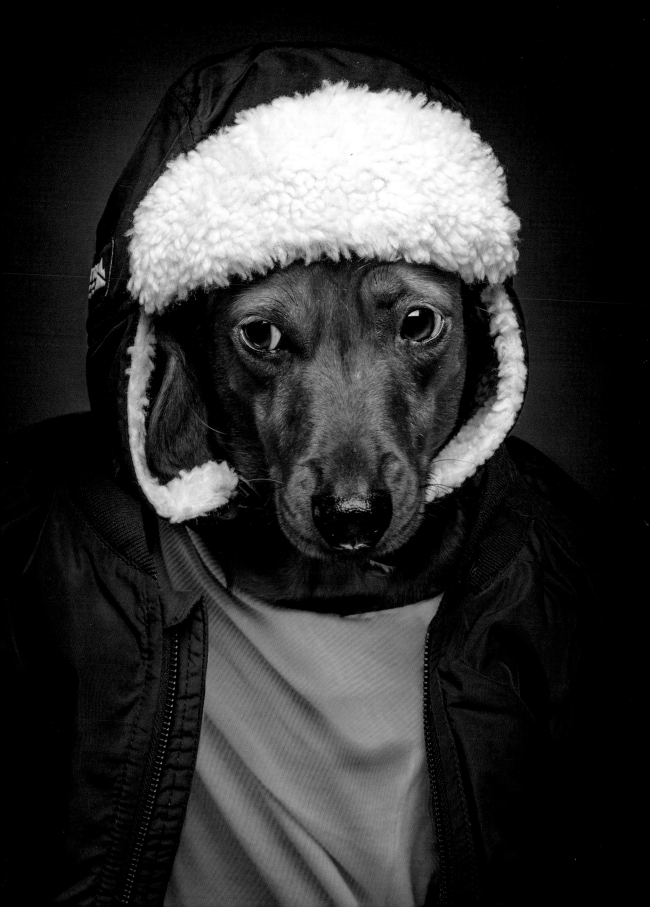

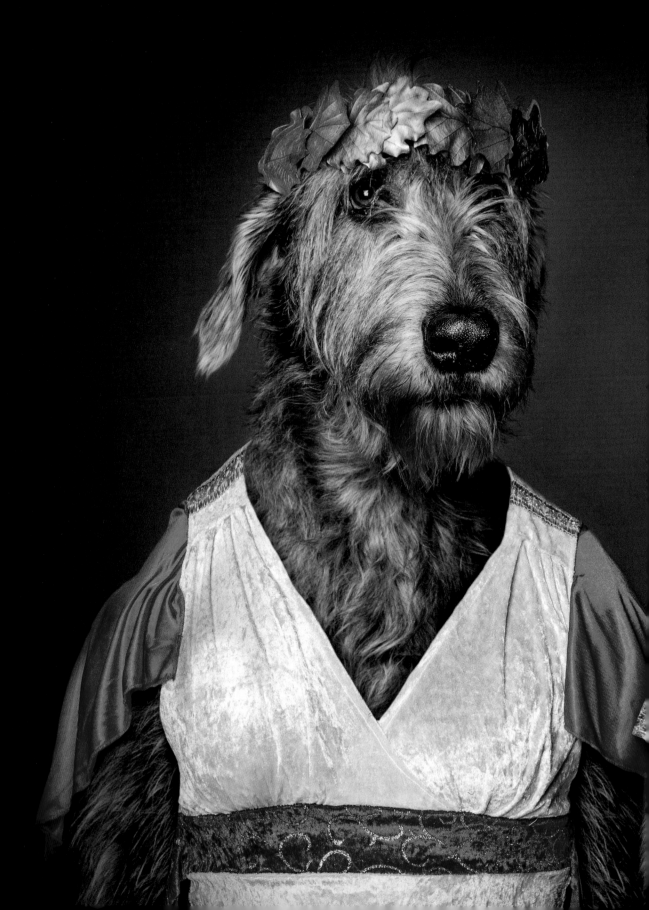

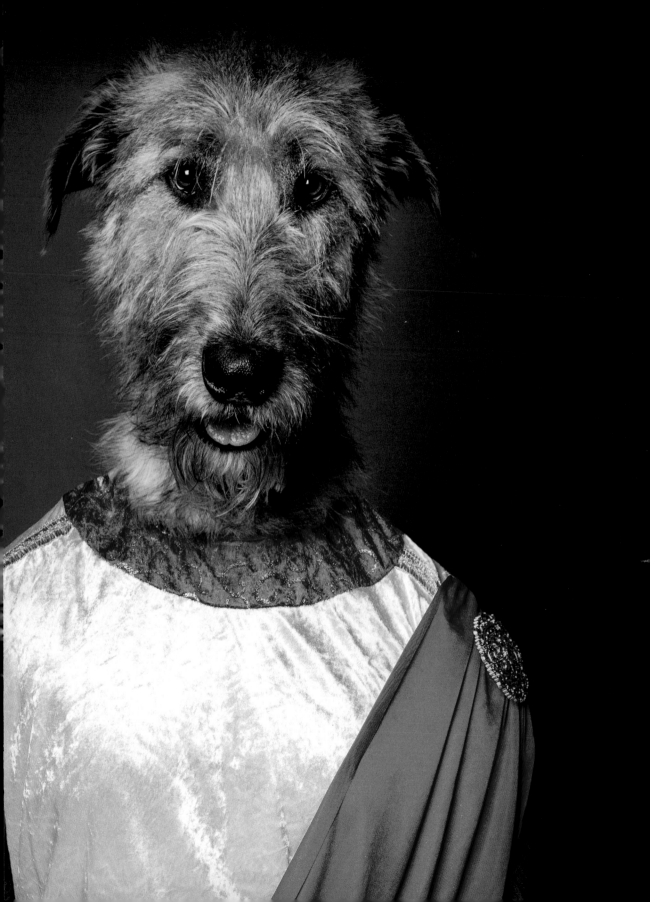

ELVIS & EMMA

Previous page

If Elvis and Emma were human... they would be clowns who are always putting on costumes. The two of them may be impressively enormous Irish Wolfhounds, but their days are chock-full of silly shenanigans. Still, to show my respect for their size and grace, I thought of Caesar of Rome for their photoshoot: "Et tu, Elvis?"

Wären Elvis und Emma Menschen... dann wären sie Clowns, die sich ständig verkleiden. Die beiden sind zwar beeindruckend große Irische Wolfshunde, machen aber den ganzen Tag nur Blödsinn. Um ihrer Größe und Anmut dennoch Respekt zu zollen, habe ich fürs Shooting an Römische Kaiser gedacht. „Auch du mein Bruder, Elvis?"

Si Elvis et Emma étaient des humains... ils seraient clowns et passeraient leur temps à se déguiser. Ces deux lévriers irlandais sont d'une taille imposante, mais ne font que des bêtises à longueur de journée. Par respect pour leur taille et leur élégance, je leur ai choisi pour le shooting des costumes d'empereurs romains. « Toi aussi, mon frère Elvis ? »

MISTERY & SPICY
(GOLDEN-CHANCE MYSTERY FOREVER & PK-HEARTBREAKERS HOT & SPICY)

Next page

If Mistery and Spicy were human... they'd be cowboys despite their noble lineage, no doubt. The two Australian Shepherds are true herding dogs, so they drive everything together that they consider their herd. But Spicy even has the cowboy look down pat already: "Just you wait, I'm gonna get you."

Wären Mistery und Spicy Menschen... dann wären sie trotz ihrer edlen Abstammung Cowboys, ganz klar. Die beiden Australian Shepherds sind natürlich auch echte Hütehunde und treiben daher alles zusammen, was sie als ihre Herde betrachten. Aber Spicy hat auch schon den richtigen Cowboy-Blick dazu: „Warte nur, dich fang ich noch."

Si Mistery et Spicy étaient des humains... ils seraient à coup sûr des cow-boys et ce, malgré leurs origines nobles. Ces deux bergers australiens sont de vrais chiens de troupeau et veillent à rassembler tout ce qu'ils considèrent comme tel. Sans compter que Spicy a clairement le regard d'un cow-boy : « Attends voir que je t'attrape aussi. »

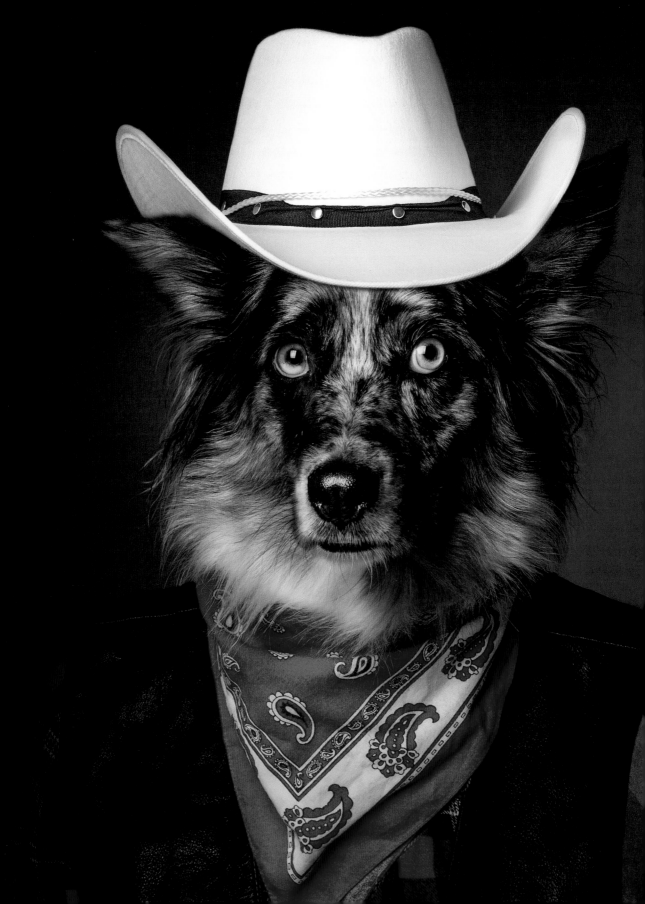

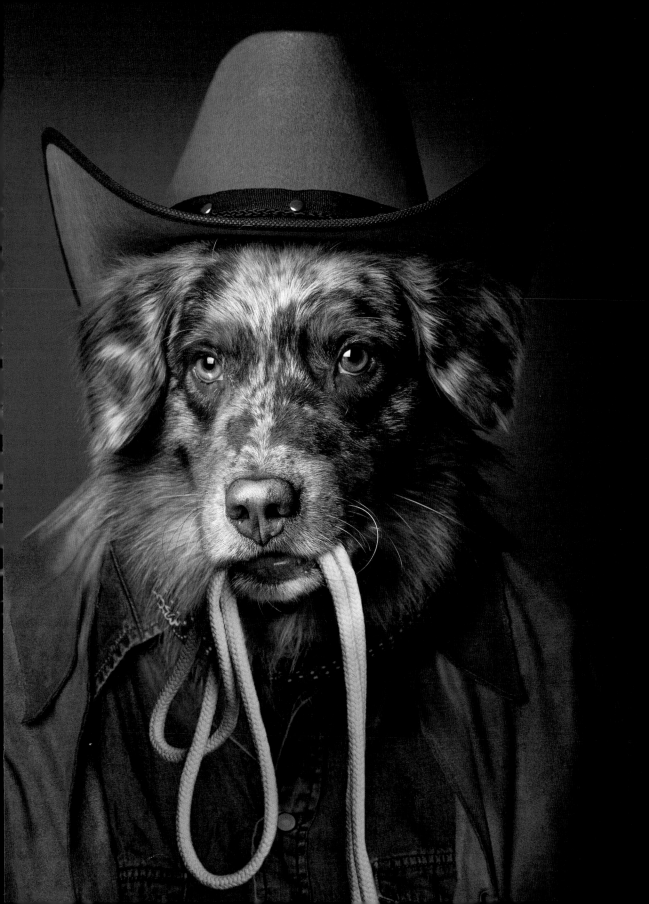

GINGER

If Ginger were human... she'd definitely be a genuine diva. Oh, so you'd think she's a born hunter because she's a Weimaraner? Ha! Somewhere along the way, Ginger's prey drive got lost. She'd much rather strike a pose and wait for applause – though always with a tragic look on her face. I know Ginger personally – and if you look up the definition of diva in Wikipedia, it becomes clear why this was the only possible choice for her: the on-line dictionary defines a diva as "an exceptional woman who knows how unique she is and celebrates this role extensively (...) sometimes in combination with complete disregard (...) of her personal sphere." That is Ginger.

Wäre Ginger ein Mensch... wäre sie ganz bestimmt eine echte Diva. Als Weimaranerin doch besser eine geborene Jägerin? Von wegen! Bei Ginger ist der Jagdtrieb irgendwo verloren gegangen. Stattdessen posiert sie lieber und lässt sich bewundern – schaut dabei aber immer höchst tragisch. Ich kenne Ginger auch persönlich – und schaut man bei Wikipedia nach, was Diva eigentlich bedeutet, wird völlig klar, warum für Ginger nichts anderes in Frage kam: In der Definition des Online-Lexikons ist eine Diva „eine herausragende Frau, die sich ihrer Einzigartigkeit bewusst ist und diese Rolle ausgiebig zelebriert (...) mitunter auch in Verbindung mit Missachtung (...) des persönlichen Umfeldes." Das ist Ginger.

Si Ginger était un humain... elle serait sûrement une diva plus vraie que nature. Mais les braques de Weimar ne sont-ils pas chasseurs dans l'âme ? On en est loin ! Ginger a manifestement perdu ses instincts de chasseur. Au lieu de cela, elle pose et se fait admirer – en adoptant toujours une allure des plus tragiques. Je connais Ginger personnellement – et, à en croire la définition d'une diva donnée par le dictionnaire, il est évident que pour elle, rien ne pourrait mieux convenir : le dictionnaire nous précise effectivement qu'une diva est « une personne éminente dans son domaine (...), se délectant de son rôle sans crainte de regarder de haut le reste du monde. » C'est bien Ginger.

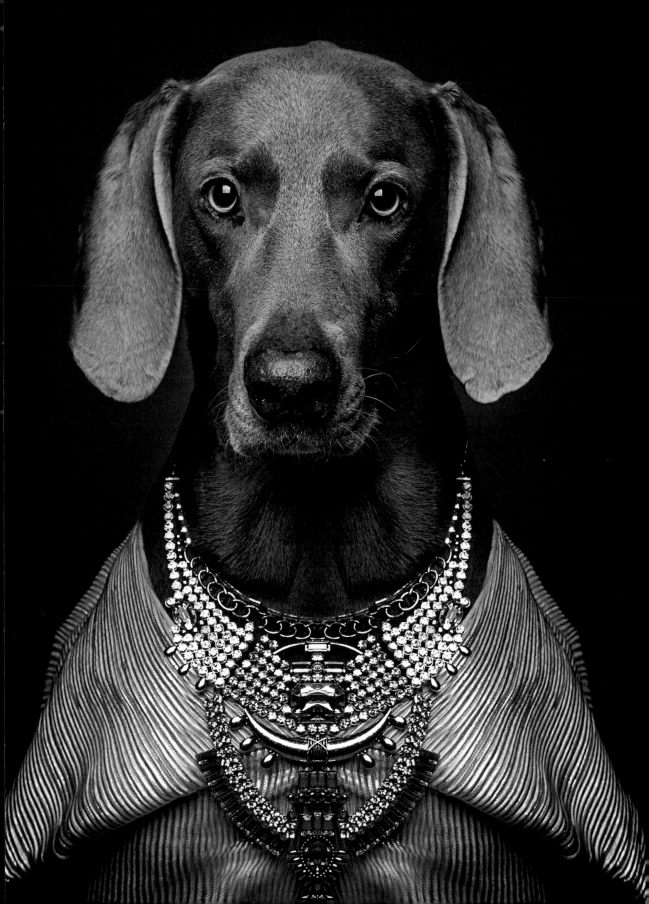

GISBERT

If Gisbert were human... he would surely be a doctor. It's the only possible explanation for the fact that the little pug, despite all his past illnesses and operations, still adores his veterinarian. With other dogs, you get them to prick their ears (as much as a pug can) by saying, "Treat! Yummy yummy treat!" With Gisbert, all you have to do is say "Dr. Uwe" and his ears immediately go up. And can't you see Gisbert as one of those wonderful older country doctors? I'd trust him in a heartbeat.

Wäre Gisbert ein Mensch... wäre er ganz sicher Arzt. Anders lässt sich nicht erklären, dass der kleine Mops schon so viele Krankengeschichten und OPs hinter sich hat und trotzdem seinen Tierarzt innig liebt. Wo man andere Hunde dazu bekommt, die Ohren zu spitzen (soweit das bei einem Mops möglich ist), wenn man „Leckerli" sagt, muss man bei Gisbert nur sagen „Dr. Uwe" und sofort gehen die Ohren hoch. Und kann man sich Gisbert nicht auch wunderbar als älteren, gemütlichen Arzt auf dem Land vorstellen? Ich würde ihm sofort vertrauen.

Si Gisbert était un humain... il serait certainement médecin. Je ne vois pas d'autre explication au fait que le petit carlin si souvent malade et avec autant d'antécédents d'opérations continue d'adorer son vétérinaire. Chez les autres chiens, il suffit souvent de prononcer le mot « bonbon » pour les voir dresser l'oreille (dans la mesure où c'est possible pour un carlin), pour Gisbert, c'est le « Dr. Uwe ». Et franchement, on n'a aucune peine à s'imaginer Gisbert comme débonnaire médecin d'un certain âge exerçant à la campagne. Personnellement, je n'hésiterais pas à lui accorder ma confiance.

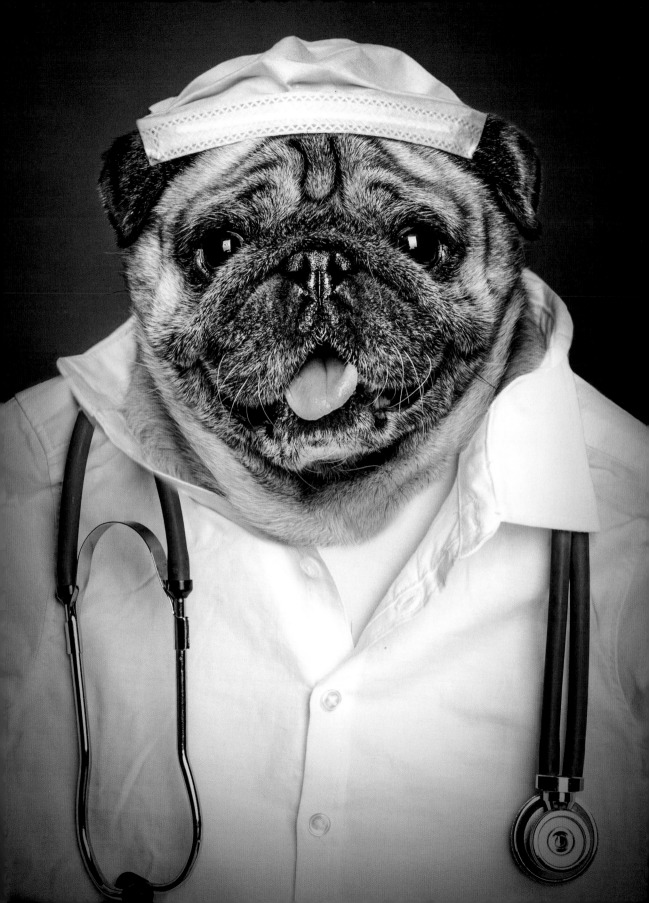

GISMO

If Gismo were human… he'd be a real rocker. But he'd be a cool sweetie, not a hard-core dangerous type – more Harley club member than evil rocker gangbanger. That's because Gismo is a typical terrier mix, a little tough guy who also has a very sensitive soul and a few medical problems to boot, unfortunately. That's why he needs a scarf around his neck – just for the photo, of course.

Wäre Gismo ein Mensch… wäre er ein echter Rocker. Aber ein cooler und lieber, kein harter und gefährlicher – eher Harley-Club als fiese Rocker-Gang. Denn Gismo ist ein typischer Terrier-Mix, ein kleiner harter Kerl, der aber ein sehr sensibles Seelchen und leider auch ein paar gesundheitliche Probleme hat. Deswegen muss der Schal um den Hals sein – nur fürs Foto natürlich.

Si Gismo était un humain… il serait un vrai rocker. Mais plutôt du type cool et sympa, pas un dur ou dangereuxgenre club Harley plutôt que méchant motard d'une bande criminelle. Car Gismo est un terrier croisé typique, un petit dur à cuire, mais aussi une âme sensible avec malheureusement quelques soucis de santé. Ce qui explique l'écharpe autour du cou – juste pour la photo, bien sûr.

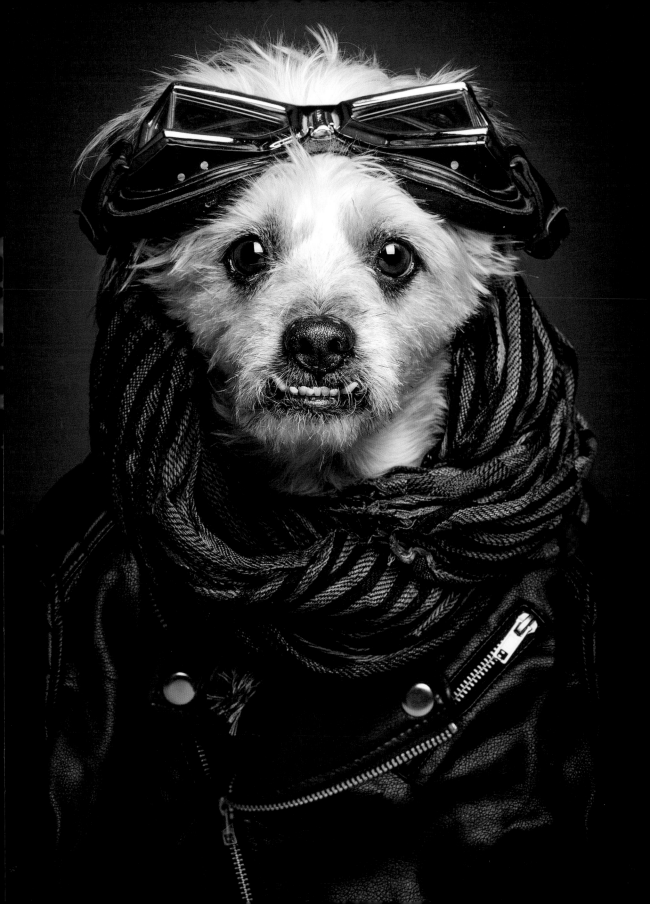

GOMEZ

If Gomez were human... he'd prefer to sleep the day away – with the thermostat turned way up, if you don't mind. (Basically, no different than his current life as a dog.) The male French Bulldog is getting on in years and gets so cold that he needs a doggy coat when he goes out in the winter so his teeth don't start chattering. Sadly, we weren't able to find him earmuffs that truly match the rest of his outfit.

Wäre Gomez ein Mensch... würde er am liebsten nur schlafen – und das bitte immer schön warm. Eigentlich kein Unterschied zu seinem Hundedasein. Der Französische-Bulldogge-Rüde ist aber auch schon ein bisschen älter und so verfroren, dass er im Winter draußen selbst als Hund ein Mäntelchen braucht, weil sonst seine Zähne anfangen zu klappern. Nur die wirklich passenden Ohrenschützer haben wir nicht gefunden.

Si Gomez était un humain... il dormirait de préférence toute la journée – et ça, bien au chaud. En fait, comme dans sa vie de chien, quoi. Mais le bouledogue français a déjà quelques années au compteur et est si frileux qu'en hiver, il lui faut son petit manteau pour sortir. Sinon, il commence à claquer des dents. Dommage qu'on n'ait pas réussi à lui trouver des cache-oreilles adaptés à son genre de beauté.

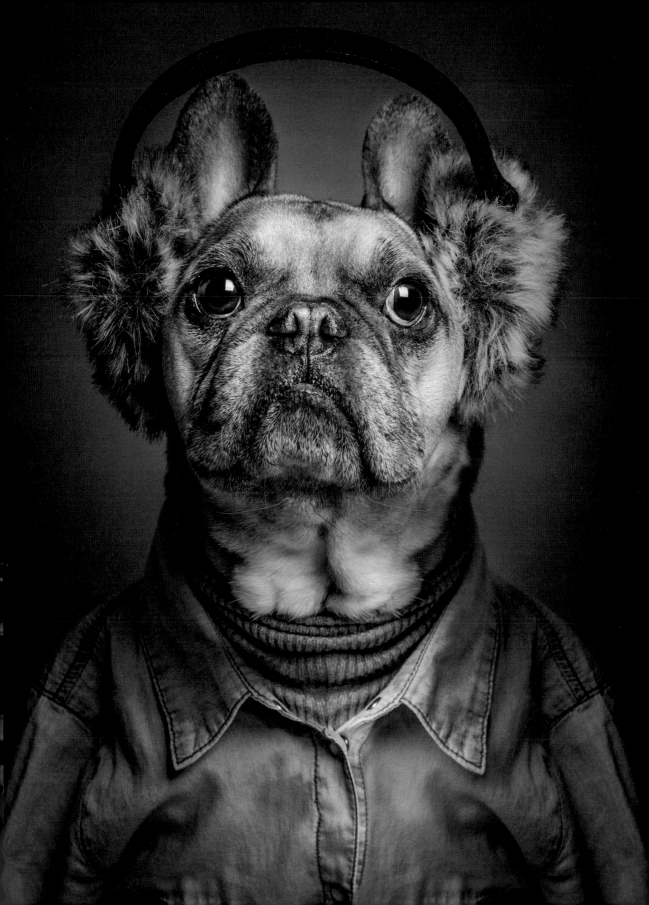

IDA
(HAIBA MASAI OF RED LION HUNTER)

If Ida were human... I am convinced she would be a seasoned businesswoman. She is a very graceful and beautiful Rhodesian Ridgeback, a little like an Amazon. So the question was, what would a businesswoman who definitely has some fight in her wear?

Wäre Ida ein Mensch... wäre sie eine gestandene Geschäftsfrau, davon bin ich überzeugt. Sie ist eine ganz anmutige, hübsche Rhodesian-Ridgeback-Hündin, ein bisschen wie eine Amazone. Die Frage war also: Wie würde sich eine Geschäftsfrau anziehen, die durchaus auch ein bisschen kämpferisch ist... ?

Si Ida était un humain... je suis convaincue qu'elle serait une femme d'affaires confirmée. C'est une chienne, aussi élégante que jolie, de race Rhodesian-Ridgeback, qui fait indéniablement penser à une amazone. La question a donc été : comment s'habillerait une femme d'affaires qui ne se laisse pas marcher sur les pieds... ?

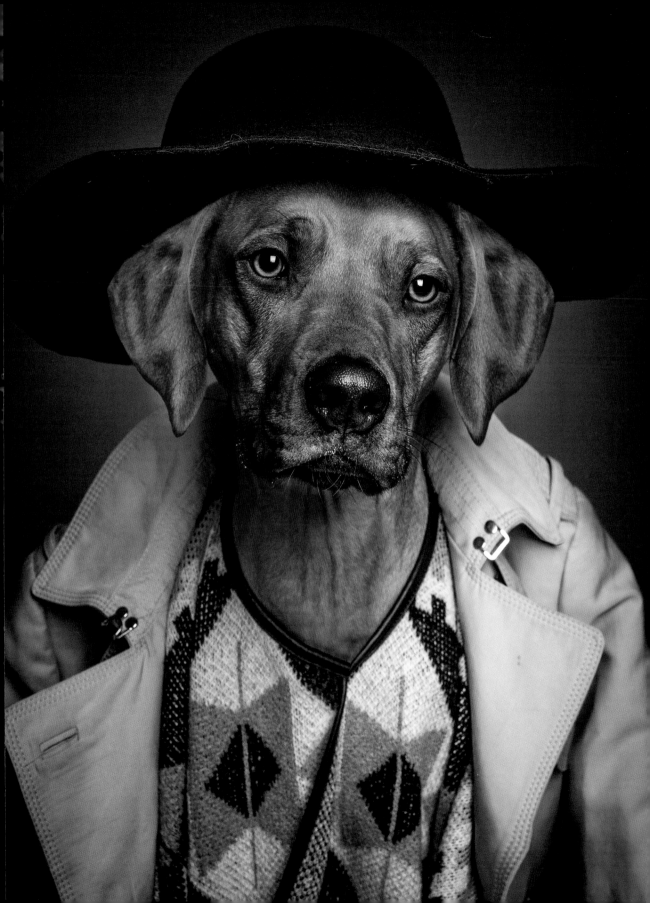

HOLLY

If Holly were human... she would be a total couch potato. The female Great Dane is as huge as she is slow, sleepy, and dreamy-eyed. Given her druthers, she would just doze the entire day away. Even when she came in for her photoshoot, she sat down, turned her head once and didn't move another inch. And didn't want to get up at the end. "I'm going to take a nice little nap – what about you?"

Wäre Holly ein Mensch... wäre sie ein totaler Couch-Potato. Die Doggen-Dame ist so riesig wie langsam, schläfrig und verträumt. Eigentlich würde sie gerne den ganzen Tag einfach so vor sich hindösen. Auch als sie zum Fotoshooting kam, hat sie sich hingesetzt, einmal den Kopf gedreht und sich nicht mehr bewegt. Und wollte auch nicht mehr aufstehen. „Ich mach Bubu, was machst du?"

Si Holly était un humain... elle serait une vraie larve de canapé. Cette femelle dogue est aussi imposante qu'elle est lente, somnolente et rêveuse. En fait, elle pourrait passer ses journées à rêvasser à moitié endormie. Lorsqu'elle est arrivée au shooting, elle s'est assise, a tourné une fois la tête et puis, n'a plus bougé. Et n'a plus voulu se lever après coup. « Je suis occupée à dormir et toi, tu fais quoi ? »

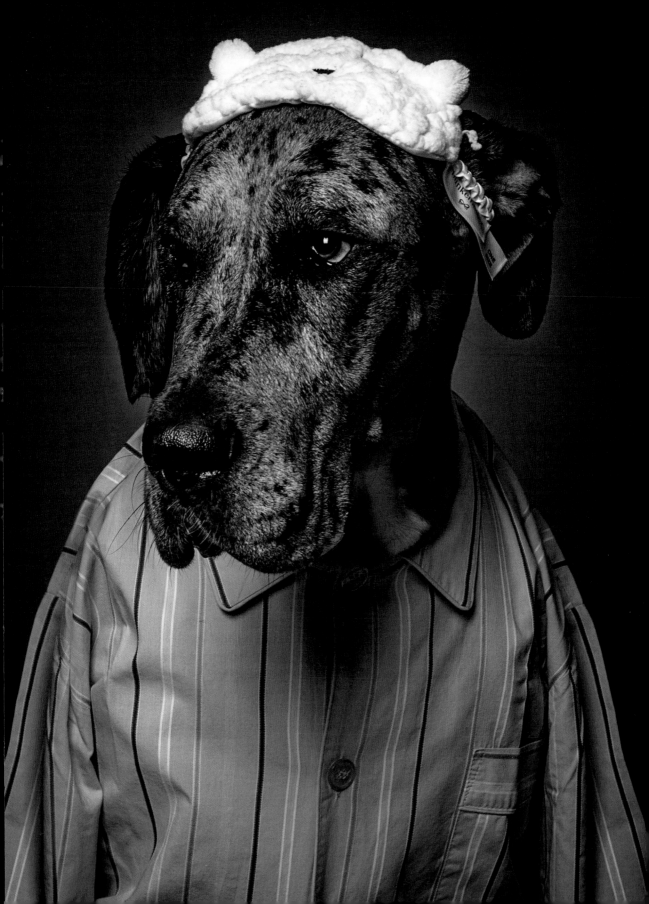

HONEY

If Honey were human... she would be "pretty bitchy and totally full of herself" – and that's what her own mistress says about the Mexican Hairless Dog mix. The very stubborn little dog thinks she is the most beautiful creature alive. She'd probably even call the small wart under her eye a beauty mark. Her motto: "Mirror, mirror on the wall, who's the fairest of them all?"

Wäre Honey ein Mensch... wäre sie „eine ziemliche Zicke und total eingebildet" – und das sagt ihr eigenes Frauchen über ihre Nackthund-Mix-Dame. Die sehr eigenwillige kleine Hündin empfindet sich selbst als die Allerschönste. Selbst die kleine Warze unter dem Auge würde sie wahrscheinlich als Schönheitsfleck bezeichnen. Ihr Motto: „Spieglein, Spieglein an der Wand, wer ist die Schönste im ganzen Land?"

Si Honey était un humain... elle serait « une vraie chipie totalement imbue d'elle-même » – c'est la description qu'en donne la propre maîtresse de l'animal, un chien nu croisé. La petite chienne est du genre capricieux et convaincue d'être la plus belle. Même la petite verrue sous l'œil serait pour elle sans doute un simple grain de beauté. Sa devise : « Miroir mon beau miroir, dis-moi qui est la plus belle en ce pays ? »

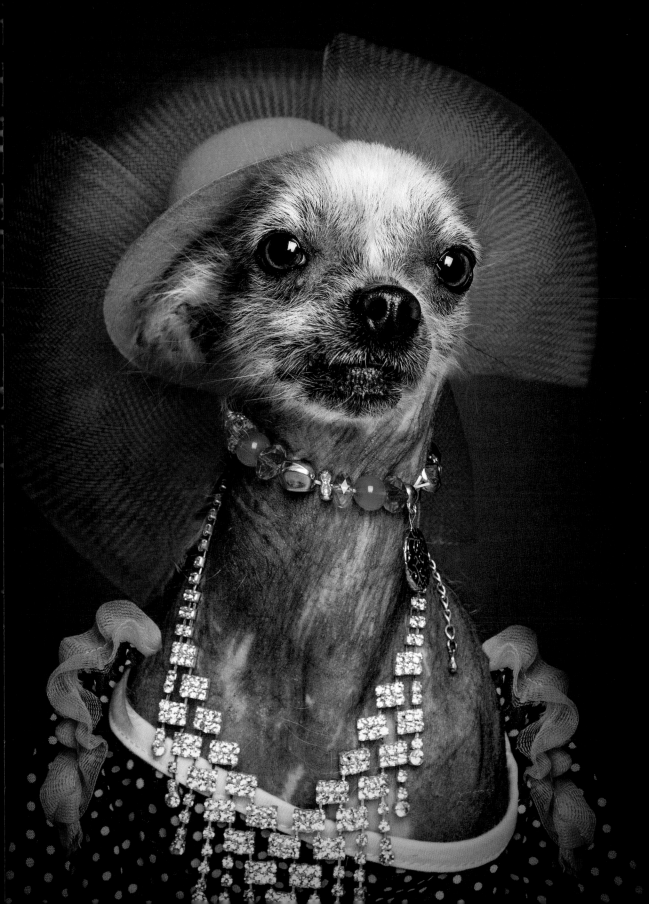

IAN
(ZOMBI FROM MARPIE´S CASTLE)

If Ian were human... he'd be exactly what he was at the time of our photoshoot: a baby just 10 weeks old who fit on the palm of my hand. His father, who also attended the photoshoot, is a full-grown American Crested Terrier with a very lively temperament. It's hard to imagine Ian becoming the same sort of rowdy creature when he's older. "I want to go back to my mommy – but okay, if you're nice to me, I guess I'll stay with you."

Wäre Ian ein Mensch... wäre er genau das, was er beim Fotoshooting auch noch war: ein gerade mal 10 Wochen altes Baby, das auf eine Handfläche passte. Sein Vater, der auch beim Fotoshooting dabei war, ist ein ausgewachsener American Crested Terrier mit sehr lebhaftem Temperament. Dass Ian auch mal so ein Draufgänger werden wird, kann man sich heute kaum vorstellen. „Ich will wieder zu meiner Mummy – aber OK, wenn du lieb zu mir bist, bleib' ich auch bei dir."

Si Ian était un humain... il serait exactement ce qu'il était au moment du shooting photo : un petit bébé de 10 semaines qui tenait dans la paume de la main. Son père, également présent lors de la séance, est un american crested terrier dynamique, avec un tempérament très affirmé. On a encore du mal à s'imaginer que Ian devienne un tel battant. « Je veux retourner chez ma maman – mais bon, si t'es sympa, je veux bien aussi rester chez toi. »

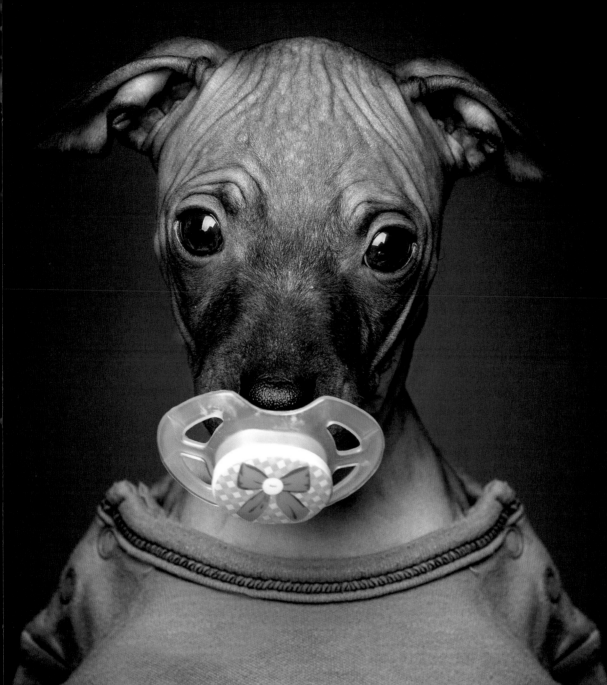

ILVIE VOM FELSENMEER

If Ilvie were human... she couldn't be anything but a true Rastafarian, but one straight out of the rainforest (no rocky caves (Felsenmeer) for her!). When the female Puli runs without a ponytail to keep the hair out of her eyes, she looks like a wild carpet ball with no definable front or back. Twigs and leaves are always part of her coat, because Ilvie loves being in the woods. She has an odd habit: when she plays, she squeaks in a very funny way – it's probably supposed to be reggae. "Get Up, Stand Up!"

Wäre Ilvie ein Mensch... könnte sie nichts anderes als eine echte Rastafarian sein. Aber eine, die direkt aus dem Urwald (nix Felsenmeer) kommt. Wenn die Puli-Dame läuft und ihre Haare nicht nach oben gebunden hat, sieht sie aus wie ein wildes Teppichknäuel, bei dem man nicht weiß, wo vorne und hinten ist. Überall in ihrem Fell hängen noch Laubreste, denn Ilvie liebt den Wald. Eine besondere Eigenart: Wenn sie spielt, quietscht sie sehr komisch – soll wahrscheinlich Reggae sein. „Get Up, Stand Up!"

Si Ilvie était un humain... elle ne pourrait être qu'une vraie Rastafarienne. Mais une de la forêt vierge (pas de la mer de rochers (Felsenmeer)). Lorsque cette chienne Puli court et que ses poils ne sont pas attachés sur le haut de la tête, elle a l'air d'un vieux tapis embroussaillé pour lequel on ne reconnaît plus ni l'envers ni l'endroit. Dans sa fourrure sont partout fichés des restes de feuilles, car Ilvie adore la forêt. Et puis, son signe distinctif : quand elle joue, elle couine bizarrement – sûrement un genre de reggae. « Que des bonnes vibes, les mecs ! »

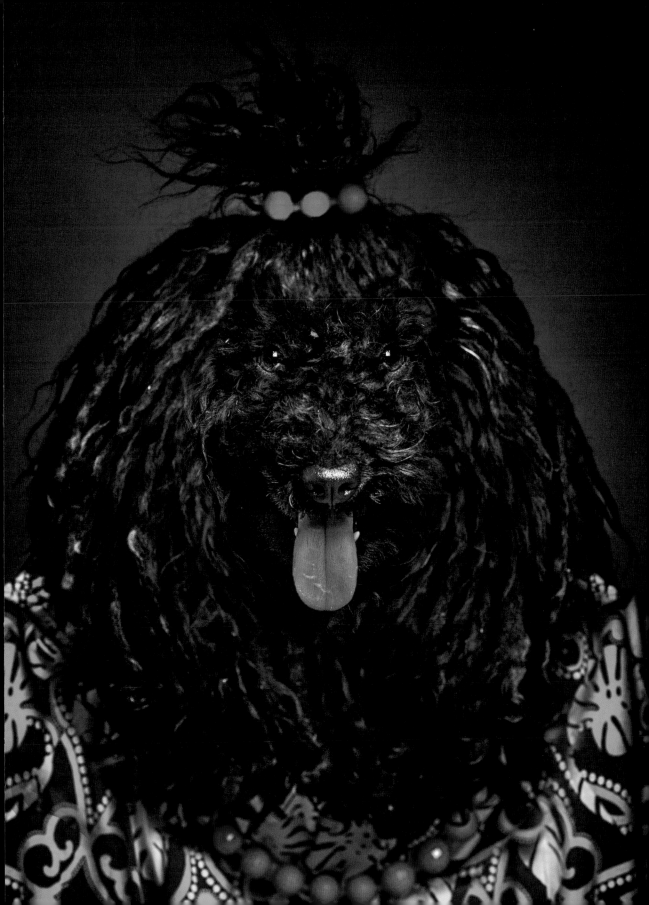

JELLA

If Jella were human... she would always, always dress warmly. The greyhound mix came from Hungary and is always half-frozen, so the clothes for her photoshoot were very welcome additions indeed. In fact, she was not at all happy that she had to give the hat and sweater back two minutes later. "Can someone please turn up the heat?"

Wäre Jella ein Mensch... würde sie sich definitiv ständig warm anziehen. Die Windhund-Mix-Dame kommt aus Ungarn und ist schrecklich verfroren. Die Verkleidung für das Fotoshooting kam ihr also gerade recht, und sie war gar nicht begeistert, dass sie nach zwei Minuten Mütze und Pullover wieder abgeben musste. „Kann mal jemand die Heizung aufdrehen?"

Si Jella était un humain... elle s'habillerait très chaudement en permanence. Cette femelle croisée lévrier est originaire de Hongrie et extrêmement frileuse. La séance photos a été pour elle une véritable aubaine et c'est la mort dans l'âme qu'elle a accepté d'enlever bonnet et pullover au bout de deux minutes. « Quelqu'un pourrait-il monter le chauffage ? »

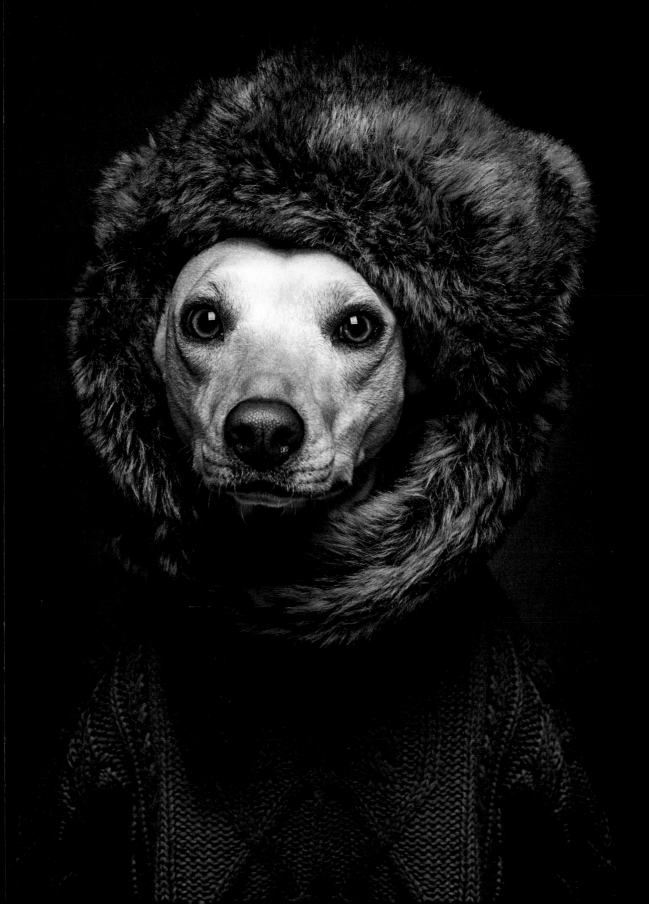

JONNY

If Jonny were human... he'd be an old swashbuckler. When the male Briard has a bad day, he barks at every dog who approaches before going after them and knocking them over. His uncle got to be a movie star with Chuck Norris in "Top Dog," so Jonny is probably also auditioning for a starring role. And the fact that he always gets along famously with the ladies doesn't hurt a bit. "People, Brad Pitt's nothing compared to me."

Wäre Jonny ein Mensch... wäre er ein alter Haudegen. Wenn der Briard-Rüde einen schlechten Tag hat, dann bellt er erst mal alle Hunde an, die ihm entgegenkommen, geht auf sie los und haut sie um. Sein Onkel hat auch schon im Film „Top Dog" mit Chuck Norris mitgespielt, wahrscheinlich will Jonny jetzt auch eine Rolle als Filmheld. Dass er sich mit den Ladies immer gut versteht, passt ganz gut dazu. „Leute, Brad Pitt ist nix gegen mich."

Si Jonny était un humain... il serait un vieux baroudeur. Lorsque ce berger de Brie a un mauvais jour, il commence par aboyer sur tous les chiens qu'il croise, se jette sur eux et les renverse. Son oncle a joué dans le film « Top Dog » aux côtés de Chuck Norris ; sans doute que Jonny rêve maintenant d'un premier rôle au cinéma. Cela dit, il a d'excellents rapports avec la gente féminine canine, ça ne peut pas être un hasard. « Brad Pitt ? Pouh, il ne m'arrive pas à la cheville. »

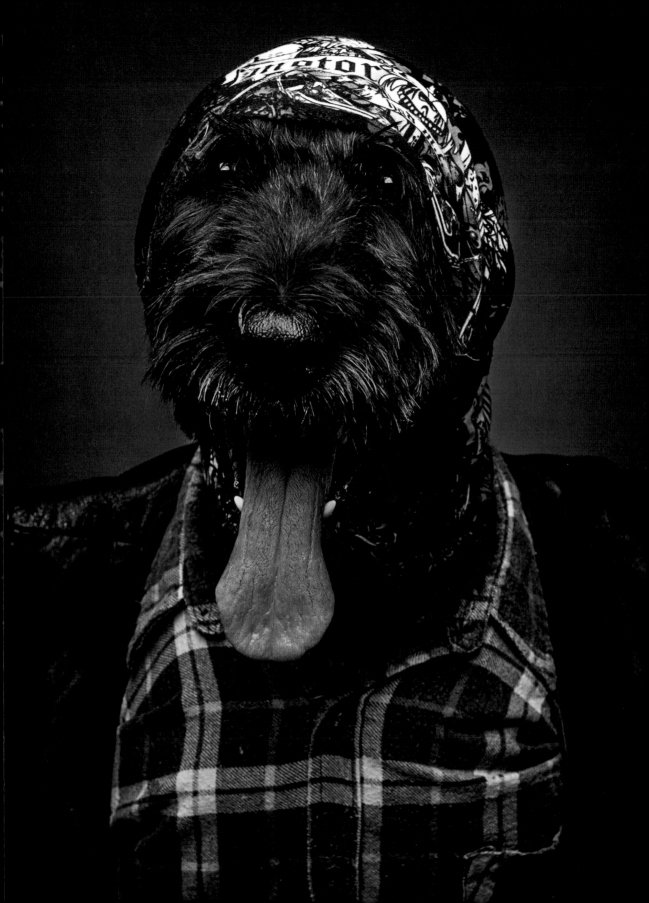

KELLY VOM WASSERSCHLÖSSLE

If Kelly were human... she would certainly be gorgeous. Her owner is convinced that "every man would turn and whistle at her." The female German Shepherd knows exactly how beautiful she is and gracefully (and willingly) accepts admiration of her soft coat. At the same time, she is a terrific buddy and would do anything for her mistress – even if her hairdo gets a little messed up in the process...

Wäre Kelly ein Mensch... wäre sie sicherlich auch wunderschön und, davon ist ihre Besitzerin überzeugt: „Jeder Mann würde sich pfeifend nach ihr umdrehen." Die Altdeutsche Schäferhündin weiß auch ganz genau, wie hübsch sie ist und nimmt die Bewunderung ihres weichen Fells gnädig (und willig) hin. Gleichzeitig ist sie aber ein prima Kumpel und würde für ihr Frauchen alles tun – auch wenn die Frisur danach nicht mehr sitzt...

Si Kelly était un humain... elle serait certainement très belle et selon sa propriétaire : « Elle se ferait siffler dans la rue et tous les hommes se retourneraient sur elle. » Cette chienne de race vieux Berger Allemand sait pertinemment combien elle est jolie et accepte de bonne grâce et quelque condescendance qu'on admire sa douce fourrure. Mais en même temps, elle est bonne copine et prête à tout pour sa maîtresse – quitte à devoir rectifier sa coiffure après coup...

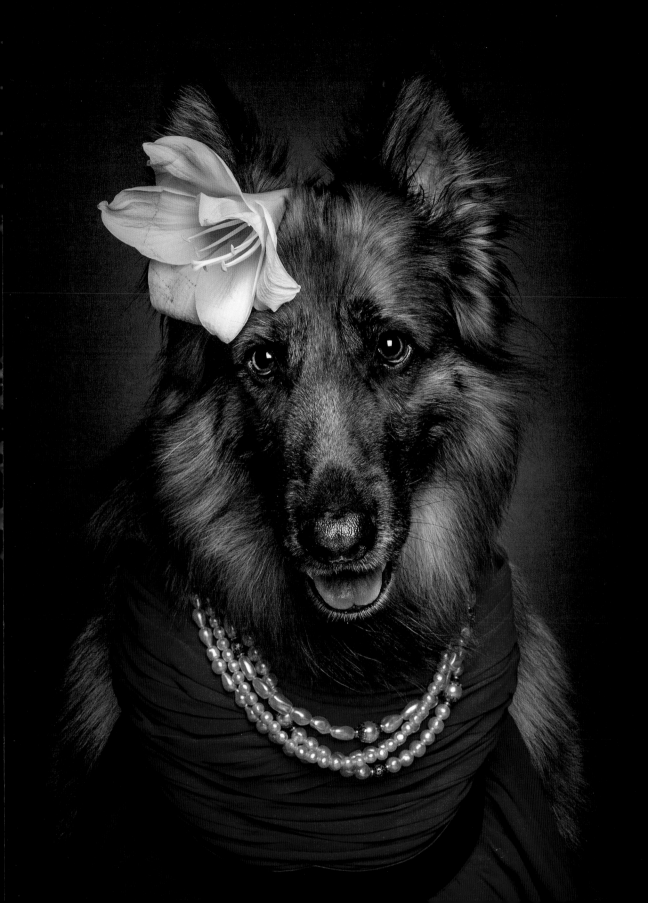

KIBA

If Kiba were human... she'd be a cheeky little girl with a big mouth. That's why we had to dress her in hot pink instead of a more muted shade. Despite her small size, the West Highland Terrier mix is very confident around large dogs, even though their heads are sometimes bigger than her whole body. But if you asked her if she's ever taken a good look at herself in the mirror, she'd probably answer, "You don't measure size in centimeters, dummy!"

Wäre Kiba ein Mensch... wäre sie ein freches kleines Mädchen mit großer Klappe. Deswegen musste es für das Bild auch so ein kräftiges Pink sein, kein sanftes Rosa. Trotz ihrer doch sehr geringen Körpergröße hat die Westhighland-Mischlings-Hündin ein sehr selbstbewusstes Auftreten gegenüber allen großen Hunden. Dabei ist die ganze Kiba so groß wie der Kopf von manch anderem. Würde man sie aber fragen, ob sie eigentlich schon mal in den Spiegel geschaut habe, wäre ihre Antwort wahrscheinlich: „Größe misst man nicht in Zentimetern, du Doofi!"

Si Kiba était un humain... elle serait une petite coquine à la langue bien pendue. Pour la photo, il fallait donc un rose fuchsia bien vif et surtout pas du rose layette. Malgré sa très petite taille, cette chienne croisée Westhighland ne perd pas une miette de son assurance même en face de plus grands chiens. Pourtant, Kiba tout entière est aussi grosse que la tête de certains autres. Et si on lui demandait si elle s'est déjà regardée dans un miroir, nul doute qu'elle répondrait : « On ne mesure pas la valeur en centimètres, pauvre cloche ! »

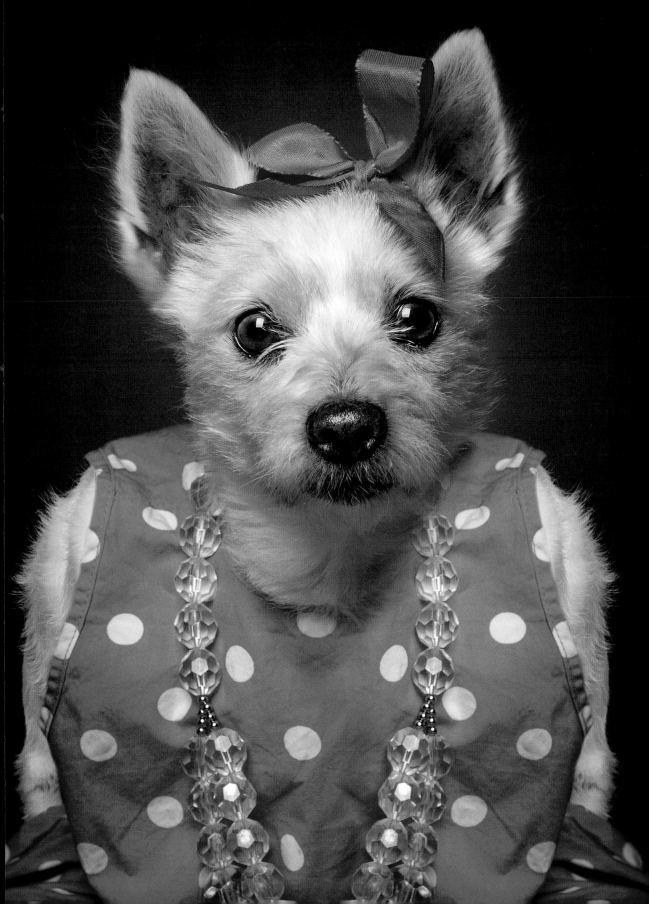

KISSY

If Kissy were human... she'd be an amazing Charleston dancer. I thought of this immediately when I saw her unbelievably long eyelashes (note the black stripes curving down from each eye: those are real lashes!). And the fact that the "flappers" of the 20s were very emancipated also fits the personality of the self-confident female terrier-schnauzer mix, who can wrap everyone around her little paw with her charm. "Helloooo there, dahling – let's dance the night away."

Wäre Kissy ein Mensch... wäre sie eine wunderschöne Charleston-Tänzerin. Das ist mir sofort eingefallen, als ich ihre extrem langen Wimpern (man beachte die schwarzen Striche, die von ihren Augen weggehen, das sind echte Wimpern!) gesehen habe. Dass diese Damen in den 20er-Jahren auch sehr emanzipiert waren, passt ganz gut zu der selbstbewussten Terrier-Schnauzer-Mix-Hündin, die mit ihrem Charme jeden um den Finger wickelt. „Halloooo du – lass uns tanzen bis zum Morgengrauen."

Si Kissy était un humain... elle serait une formidable danseuse de charleston. C'est ce que j'ai tout de suite pensé lorsque j'ai vu ses cils extrêmement longs (les poils noirs qui partent de ses yeux sont de vrais cils !). Et lorsqu'on sait que, dans les années 20, ces dames étaient également très émancipées, on n'a plus aucun doute : cette chienne croisée terrier schnauzer ne manque en effet ni d'assurance ni de charme et mène son monde par le bout du nez. « Salut, toi – la nuit sera longue, crois-moi... »

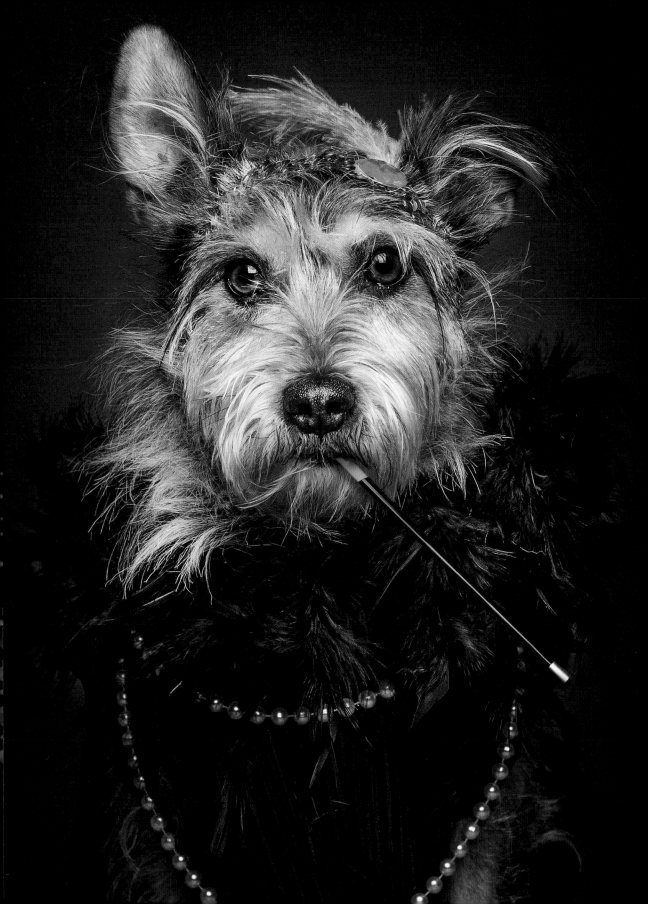

KLARA

If Klara were human... she'd probably work as a forester, just like her master. The mixed-breed female loves to go with her owner into the woods and always wants to lend a helping paw. Usually, she only manages to fell small branches rather than whole trees, but it's the thought that counts. "Tiiiimber – look out, get out of the way."

Wäre Klara ein Mensch... würde sie bestimmt wie ihr Herrchen als Forstwirt arbeiten. Die Mischlingsdame liebt es, ihren Besitzer fast jeden Tag in den Wald zu begleiten, und möchte immer helfen. Allerdings schafft sie es dann doch eher nur kleine Stöckchen statt ganzer Bäume zu bearbeiten. Aber was zählt, ist ja der gute Wille. „Achtung, Baum fällt – macht mal Platz."

Si Klara était un humain... elle travaillerait sûrement comme forestier, tel son maître. Cette bâtarde adore accompagner son propriétaire dans les bois presque tous les jours et est toujours prête à aider. Cela dit, elle s'affaire avec les petits bouts de bois plutôt qu'avec les grands arbres. Mais ce qui compte, c'est la bonne volonté. « Attention à l'arbre – pousse-toi de là. »

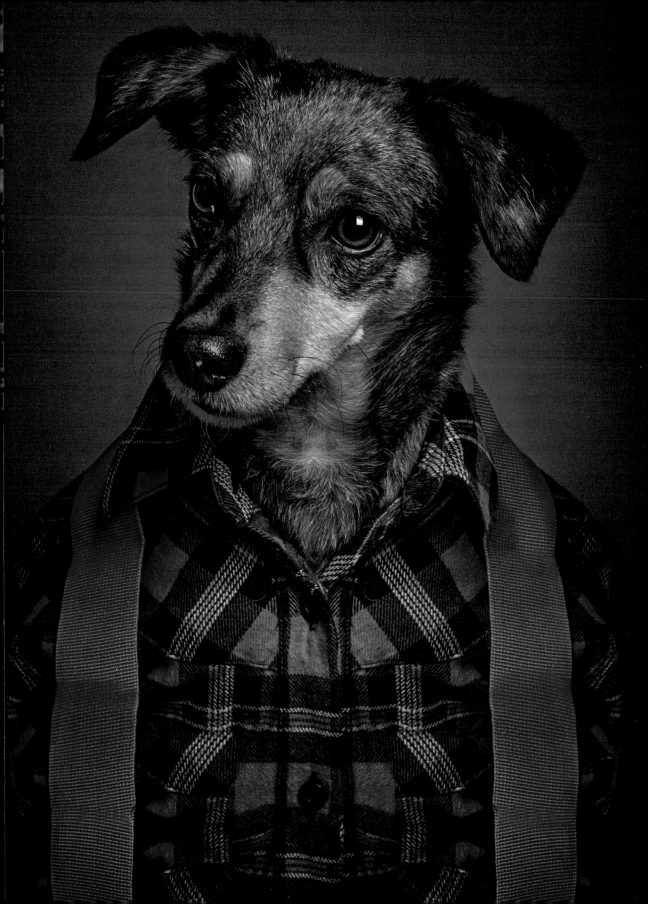

LENI

If Leni were human... she'd absolutely be a boy. Her owner wrote me before the photoshoot that her female Australian Shepherd Leni was actually a boy in disguise. She lifts her leg, attempts to dominate others, and is a real daredevil. "I'm a real boy, and you'd better believe it or else!"

Wäre Leni ein Mensch... wäre sie auf alle Fälle ein Junge. Die Besitzerin hat mir schon vor dem Fotoshooting geschrieben, dass ihre Australian-Shepherd-Hündin Leni eine verkappte Rüdin sei. Sie hebt ihr Bein, zeigt anderen gegenüber immer Imponiergehabe und ist ein richtiger Draufgänger. „Ich bin ein ganzer Kerl, und wehe, du glaubst das nicht!"

Si Leni était un humain... elle serait dans tous les cas un garçon. Sa propriétaire m'a écrit avant le shooting que Leni était en fait un mâle refoulé. Elle lève la patte, fait de l'esbroufe dès qu'elle croise d'autres et est une vraie tête brûlée. « Je suis un vrai mec et gare à toi si tu ne me crois pas ! »

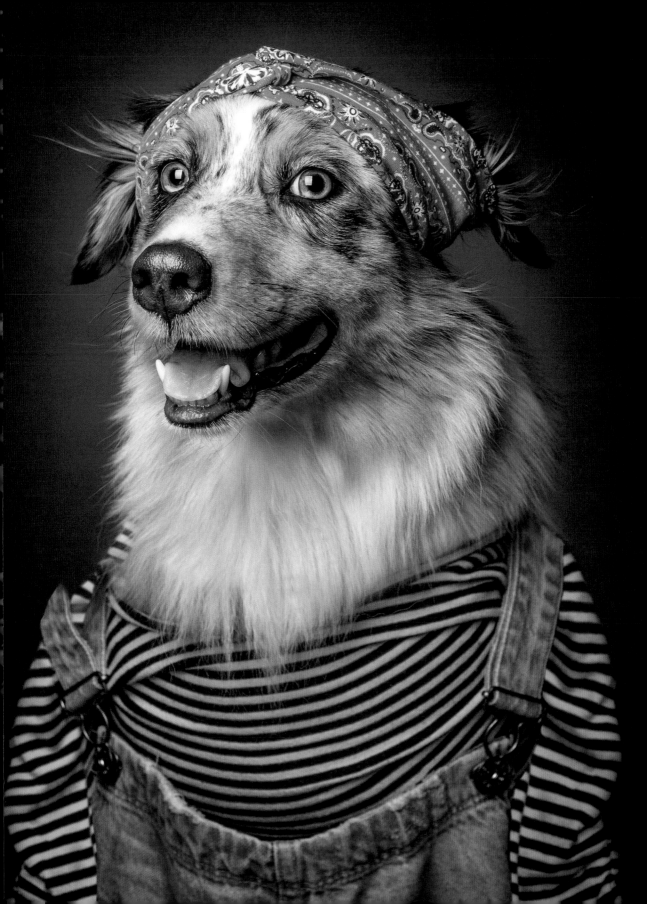

LEO

If Leo were human... he'd definitely be a gardener. Even in his current life as a dog, the Labrador mix feels responsible for his garden, with a few small hiccups – he doesn't quite understand that you don't dig up plants, and buried bones don't turn into bone bushes. But he might yet figure it all out before his next life. "Hey, come on down to my garden, it's fun!"

Wäre Leo ein Mensch... wäre er sicher Gärtner. Denn eigentlich fühlt sich der Labrador-Mix schon in diesem Leben als Hund für seinen Garten verantwortlich – nur, dass er noch nicht so ganz verstanden hat, dass man Pflanzen nicht ausbuddelt und vergrabene Knochen nicht anwachsen. Aber das kann ja alles noch werden bis zum nächsten Leben. „Los, kommt mit in meinen Garten, das macht Spaß!"

Si Leo était un humain... il serait certainement jardinier. Car ce croisé labrador se sent manifestement responsable de son jardin dans sa vie actuelle de chien – juste qu'il n'a pas encore bien compris qu'on ne déterre pas les plantes et que les os soigneusement enfouis ne poussent pas. Enfin bon, il y a peut-être de l'espoir pour la prochaine vie. « Viens donc avec moi dans mon jardin, on y est trop bien ! »

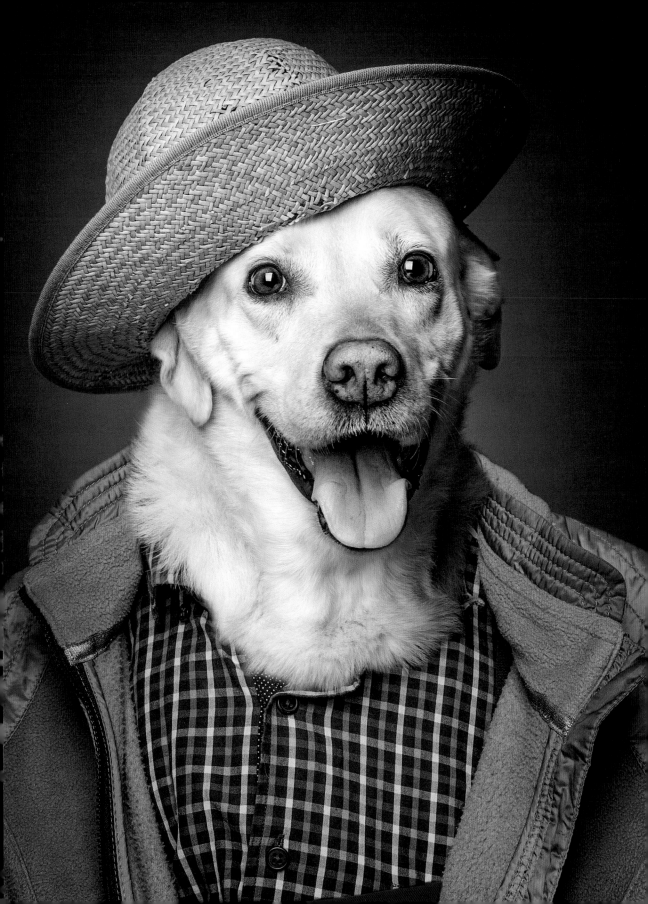

LITTLE JOHN

If Little John were human... he'd be a terrific member of Freddie's (page 58/59) street gang. Maybe he'd own a club – or at least be a bouncer. Of course, the Old English Bulldog looks "bullish," but he's totally relaxed – and I thought it would be fitting for him to have some fashion sense: a black skull-and-crossbones jogging suit with a silver cross – totally cool. "Hey, you're not getting in here unless I say it's OK."

Wäre Little John ein Mensch... wäre er ein prima Mitglied der Straßengang von Freddie (Seite 58/59). Vielleicht als Clubbesitzer – zumindest aber Türsteher. Der Olde English Bulldog sieht natürlich „bullig" aus, ist aber völlig entspannt – und ich fand, zu ihm passt auch ein bisschen Modebewusstsein: schwarzer Totenkopf-Jogger mit Silberkreuz – total cool. „Hey Leute, hier darf nur rein, wer mein OK bekommt."

Si Little John était un humain... il ferait certainement partie du gang de rue de Freddie (page 58/59). Peut-être comme propriétaire de club – mais au moins comme videur. Ce vieux bouledogue anglais a certes l'air aussi aimable qu'un bouledogue, n'en est pas moins hyper relax – j'ai pensé qu'il fallait le mettre un peu dans l'ambiance : jogger noir à tête de mort avec croix en argent – trop cool. « Eh les mecs, c'est moi le boss ici et je décide si vous rentrez ou pas. »

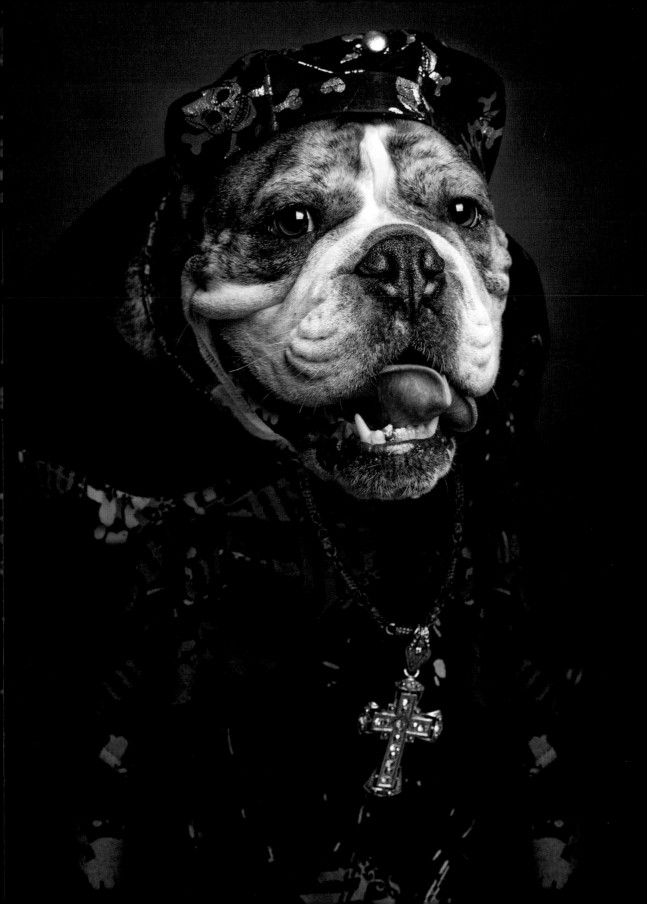

ROMERO LIVONIJA BARON CESAR

If Romero were human... he'd surely work on a security team like his master, who is training the Doberman male as a protection dog. Note the word "protection," which is not the same as "attack." Which we can't imagine Romero doing anyway with the crazy outfit we've put on him: "Just wait until I'm done with my training, and then all you burglars will be trembling in fear!"

Wäre Romero ein Mensch... würde er sicher in einem Security-Team arbeiten wie sein Herrchen. Von dem wird der Dobermann-Rüde jetzt auch als Schutzhund ausgebildet und ist voll bei der Sache. Wohlgemerkt „Schutzhund" – und schützen heißt nicht nur angreifen –, was man sich bei Romero, wenn er wie hier von uns so unmöglich verkleidet, ohnehin nicht vorstellen kann: „Wartet mal ab, bis ich mit der Ausbildung fertig bin, dann werdet ihr zittern, ihr Einbrecher!"

Si Romero était un humain... il travaillerait sûrement dans une équipe de sécurité, comme son maître. Celui-ci forme actuellement son doberman comme chien de protection. Lequel est tout à fait dans son élément. À noter que « chien de protection » – et protéger ne signifie pas seulement attaquer – ce qui, chez Romero, quand on le déguise comme ça de manière aussi officielle, est difficile à s'imaginer : « Attendez voir que je finisse ma formation... Vous pouvez déjà trembler, malheureux cambrioleurs ! »

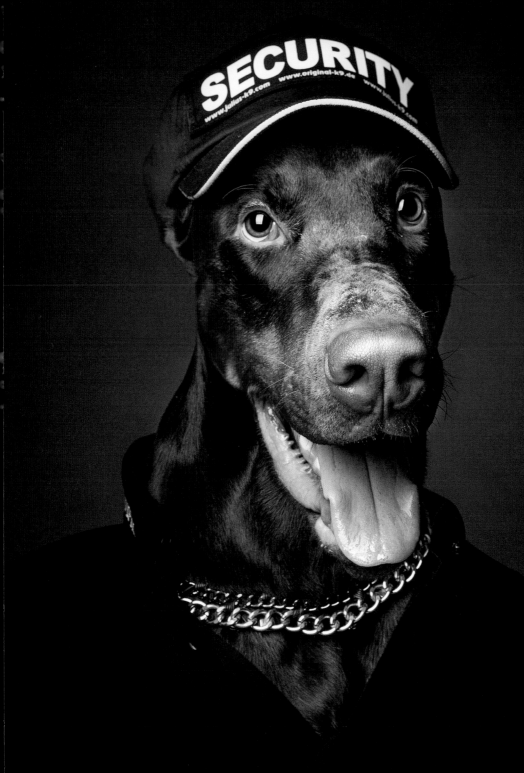

LODOS VOM STÖPPACHBERG

If Lodos were human... he'd be a mountain biker for sure. As a dog, he can only run along beside the bike, but that is the Dalmatian's absolute favorite thing to do. Of course, a helmet is not required for that, but Lodos would wear it well, don't you think? "The next BIKE-Transalp winner? Me!"

Wäre Lodos ein Mensch... dann wäre er ganz klar ein Mountainbiker. Als Hund muss er zwar noch neben dem Fahrrad herlaufen – aber das ist tatsächlich die größte Leidenschaft des Dalmatiner-Rüden. Helmpflicht gibt es dafür natürlich noch nicht, aber Lodos könnte ihn gut tragen, oder? „Die nächste BIKE-Transalp (Klassiker unter den Mountainbike-Rennen) gewinne ich!"

Si Lodos était un humain... il serait évidemment un adepte du VTT. En sa qualité de chien, il n'a pas d'autre choix que de courir à côté du vélo – mais c'est vraiment la plus grande passion du dalmatien. Le port du casque n'est pas encore obligatoire, ça lui va pourtant comme un gant, non ? « J'ai toutes mes chances pour la prochaine épreuve du BIKE-Transalp ! »

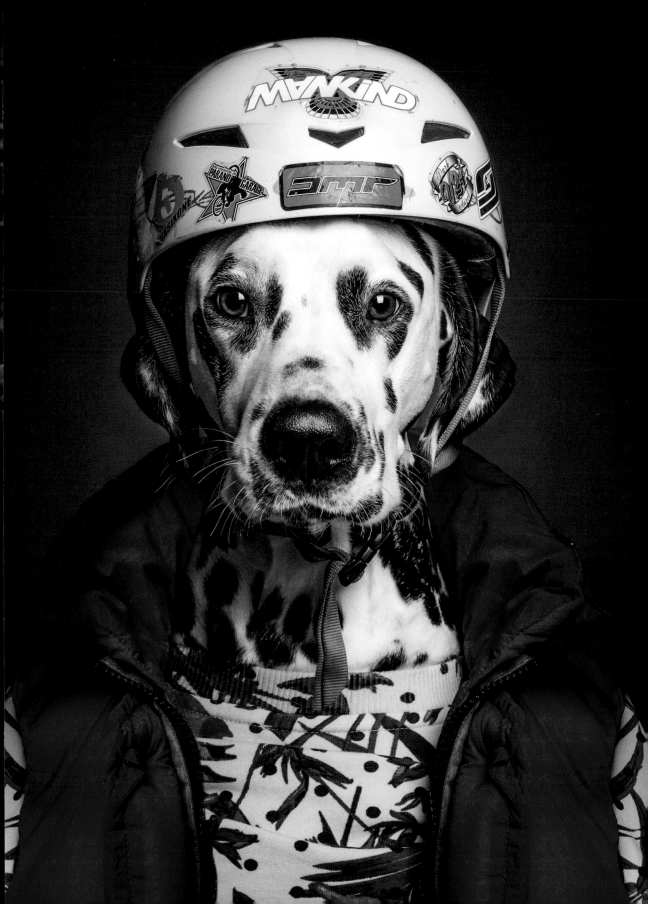

LOTTE

If Lotte were human... she'd be a little dominatrix. Lotte, who combines the genetic bullheadedness of the French Bulldog and Boxer, always wants to be the boss – and she tends to express that feeling rather forcefully to those around her. She would definitely want to audition for a role in Fifty Shades of Grey. She used our photoshoot as her first screen test. "So, little one, would you like to... play?"

Wäre Lotte ein Mensch... wäre sie eine kleine Domina. Die Hündin, bei der die genetischen Dickköpfe von Französischer Bulldogge und Boxer zusammenkommen, will immer der Chef sein – und dabei geht sie auch nicht gerade zimperlich mit anderen um. Sie würde sich sicher auch für eine Rolle bei Fifty Shades of Grey bewerben. Jedenfalls hat sie unser Fotoshooting schon mal als ersten Test genutzt. „Na Kleiner, Spielchen gefällig?"

Si Lotte était un humain... elle serait une petite domina. Cette chienne qui combine les grosses têtes caractéristiques du bouledogue français et du boxer, cherche toujours à jouer les petits chefs – et ne prend pas de gants avec les autres. Elle postulerait certainement à un rôle dans « Fifty Shades of Grey ». En tout cas, elle a profité de notre shooting photo pour faire un premier test. « Eh ben mon gars, t'as pas envie d'un p'tit jeu ? »

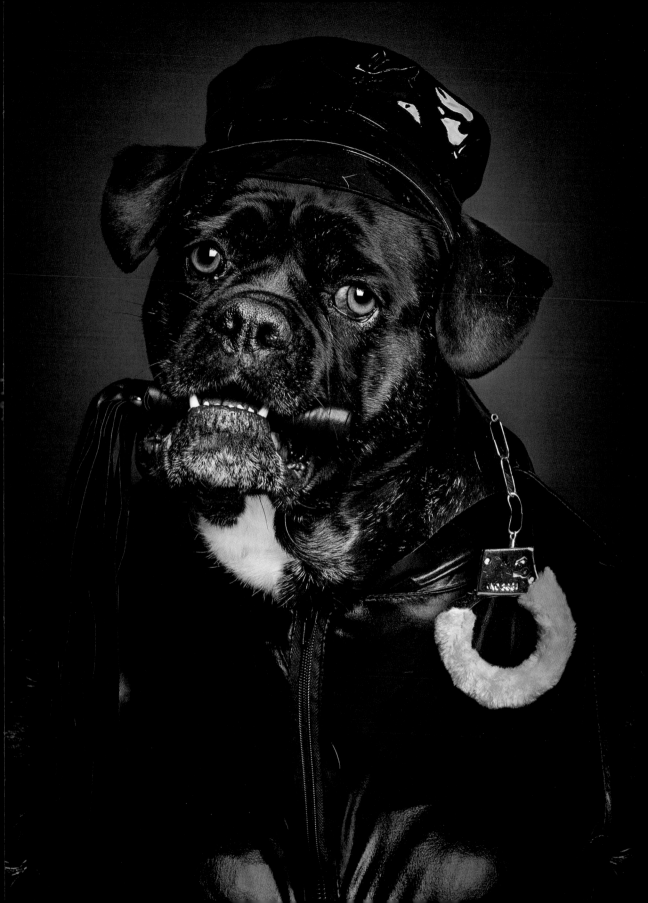

LUCA

If Luca were human... she might be a TV host. You don't have to be thin as a rail and wrinkle-free for that job these days, do you? The female Shar-Pei is always happy and entertains everyone around her all day long. Could she be the next Rosie O'Donnell? "OK, you can all have my autograph!"

Wäre Luca ein Mensch... wäre sie vielleicht Fernsehmoderatorin. Dazu muss man ja heute nicht mehr spindeldürr und faltenlos sein, oder? Dafür ist die Shar-Pei-Hündin immer fröhlich und unterhält ihre Umgebung den ganzen Tag. Die neue Cindy aus Marzahn? „OK, ihr bekommt alle ein Autogramm!"

Si Luca était un humain... elle serait peut-être animatrice à la télévision. De nos jours, il ne faut plus être mince comme un fil et sans une ride, non ? Cette chienne Shar Pei est toujours de bonne humeur et divertit son entourage à longueur de journée. Le nouveau boute-en-train de la télé ? « OK, je vous donne un autographe ! »

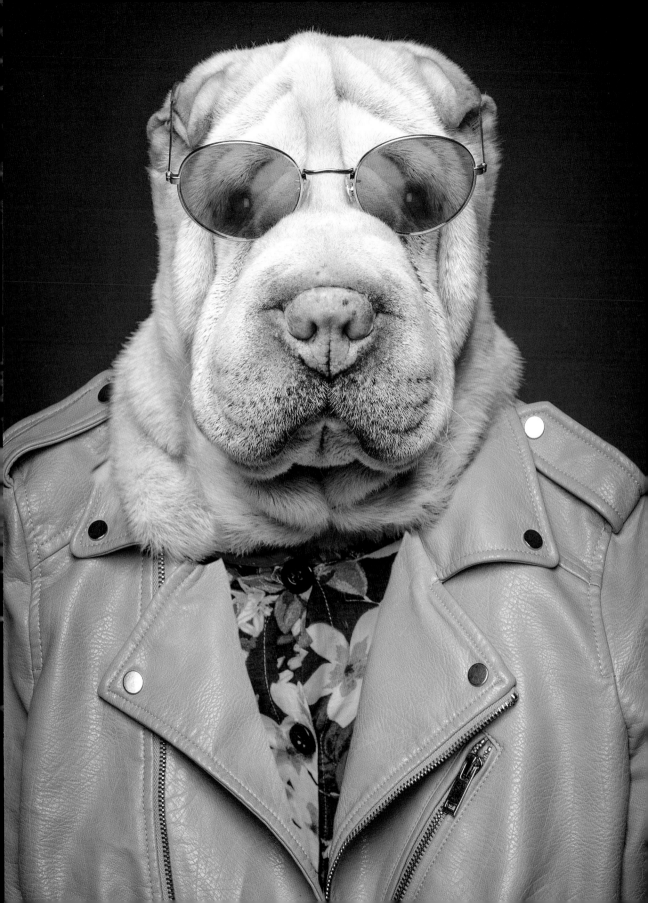

MAJA

If Maja were human... oh boy, I really had a hard time deciding what she would be. Maja is my very own dog, a wonderful and beautiful Bernese Mountain Dog mix. Of course, every owner is firmly convinced that his or her own dog is the loveliest. I freely admit my bias and crown her "Miss Dog People." Because who you know matters – even if you're a dog.

Wäre Maja ein Mensch... ach je, da ist es mir schwergefallen zu entscheiden, wie ich sie darstellen sollte. Denn Maja ist meine eigene Hündin, ein wunderschöner Berner-Sennen-Mix. Aber als Besitzer ist man ja ohnehin der Meinung, der eigene Hund sei der Schönste. Ich bin daher absolut parteiisch und küre sie zur „Miss Dog People". Beziehungen sind halt doch wichtig – auch im Hundeleben.

Si Maja était un humain... ah là là, j'ai eu bien du mal à décider comment la représenter. Car Maja est ma propre chienne, un magnifique bouvier bernois mâtiné. Comme propriétaire, on est de toute façon convaincu que son chien est le plus beau. Je suis donc totalement partiale et lui décerne le titre de « Miss Dog People ». Les relations sont quelque chose d'important – même dans une vie de chien...

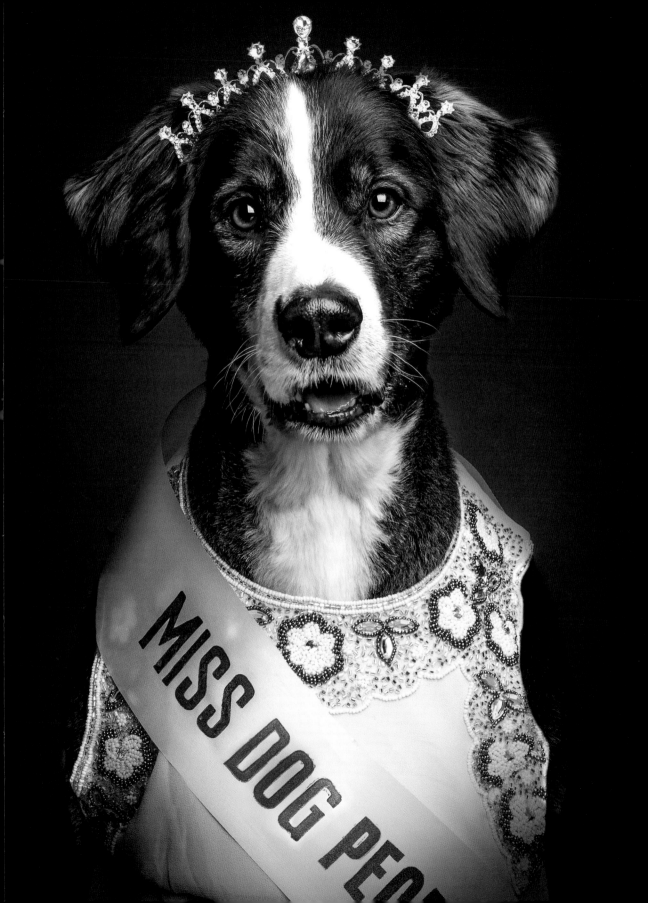

MERLE

If Merle were human... she'd be a professional hockey player. She is crazy about the puck and always tries to steal it away from her master, who plays ice hockey recreationally. Every attempt to break her of this habit (since the hard pucks have worn down her teeth) has failed miserably. Even after we finished her photoshoot, she was very reluctant to give up her prize.

Wäre Merle ein Mensch... wäre sie Eishockeyprofi. Sie ist ganz wild auf den Puck und versucht ihn ihrem Besitzer, der hobbymäßig Eishockey spielt, immer abzujagen. Jeder Versuch, ihr das abzugewöhnen, weil sie sich mit den harten Pucks schon die Zähne ein wenig abgeschliffen hat, war bisher vergeblich. Auch nach dem Shooting wollte sie ihre Beute nur ungern wieder abgeben.

Si Merle était un humain... elle serait joueuse de hockey sur glace professionnelle. Le palet la met toujours en joie et elle n'a de cesse de le piquer à son propriétaire qui pratique ce sport pendant ses loisirs. Toutes les tentatives de lui faire perdre cette mauvaise habitude – car elle s'est déjà un peu abrasé les dents avec le palet très dur, ont jusque-là échoué. Et même après le shooting, elle a eu bien du mal à rendre son butin.

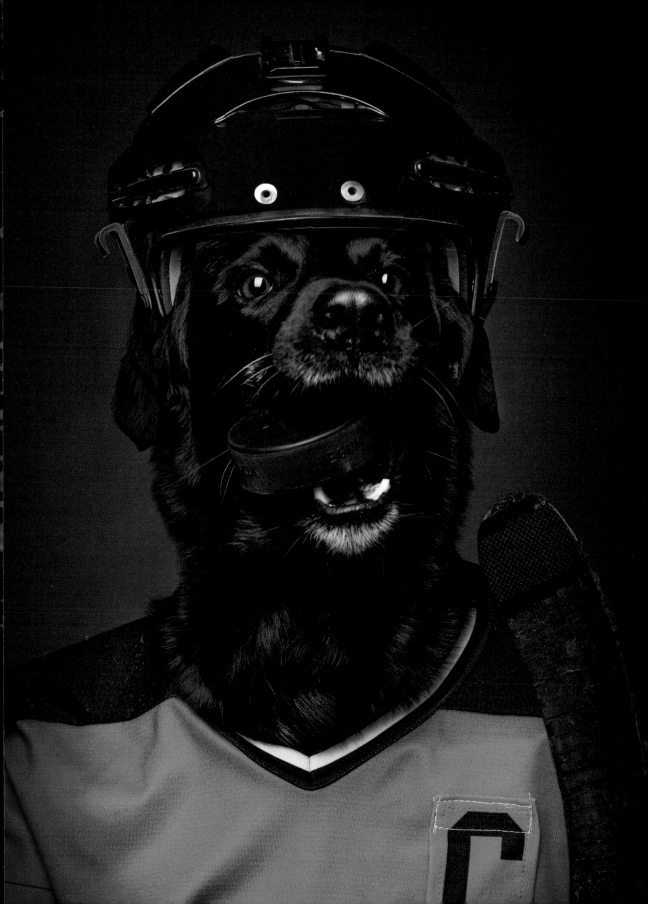

MERLIN

If Merlin were human... he'd be a very elderly grand-father who pretty much lives in his recliner – unless he is going out to eat with a lovely lady. That's why I wanted to turn this senior Pug into a fashionable grandpa with a bow-tie and hat. He liked it and didn't even bother getting up after that. "It's not that often you get all gussied up like this anymore, dear ladies."

Wäre Merlin ein Mensch... wäre er ein sehr alter Opa, der eigentlich nur noch auf seinem Sessel hockt – außer, wenn es mit einer feinen Lady zum Essen geht. Deswegen wollte ich den Mops-Oldie wenigstens zu einem schicken Opi mit Fliege und Hut machen. Fand er gut, er ist gar nicht mehr aufgestanden: „So oft putzt man sich ja auch nicht mehr raus, meine Damen."

Si Merlin était un humain... il serait un très vieux papy qui ne bougerait presque pas de son fauteuil préféré – sauf pour sortir dîner avec une jolie femme. C'est ce qui explique pourquoi j'ai choisi de faire de ce carlin vieillissant un papy chic avec nœud papillon et chapeau. Merlin a trouvé ça à son goût et ne s'est plus levé. « Les occasions de se mettre sur son trente et un se font rares, mesdames. »

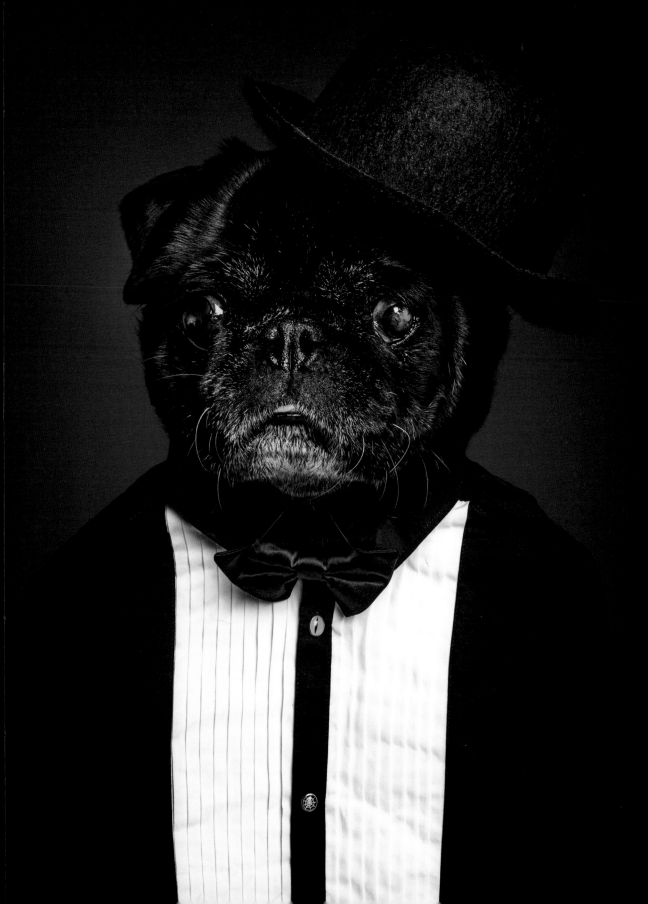

MEXX

If Mexx were human... he'd be the poster child for a rehabilitated criminal. His current owner is a police K9 handler. When his police dog died, he adopted Mexx, a male Malinois, from the shelter. Mexx landed in the shelter after having terrible experiences with people. He was considered very aggressive and had bitten people out of fear. But now he is in good hands, is being assiduously trained, and is much calmer as a result – and who knows, maybe he'll make a career out of it yet.

Wäre Mexx ein Mensch... wäre er das Musterbeispiel eines rehabilitierten Straftäters. Sein heutiger Besitzer ist Justizhundeführer bei der K9. Als sein Arbeitshund starb, hat er den Malinois-Rüden Mexx aus dem Tierheim adoptiert. Dort war dieser nach ziemlich schlechten Erfahrungen mit Menschen gelandet, galt als sehr aggressiv und hat auch schon mal aus Angst zugeschnappt. Doch jetzt ist er in guten Händen, wird fleißig trainiert ist viel ausgeglichener – und wer weiß, vielleicht macht er noch Karriere.

Si Mexx était un humain... il serait l'exemple modèle d'un délinquant réhabilité. Son propriétaire actuel travaille comme maître-chien dans la justice. Lorsque son chien de travail l'a quitté, il a adopté ce berger malinois dans un refuge. Après d'assez mauvaises expériences avec des humains, Mexx passait pour très agressif et il lui est arrivé de mordre par peur. Aujourd'hui, il est en de bonnes mains, son maître l'entraîne sérieusement et il est bien plus équilibré. Qui sait, peut-être fera-t-il encore carrière...

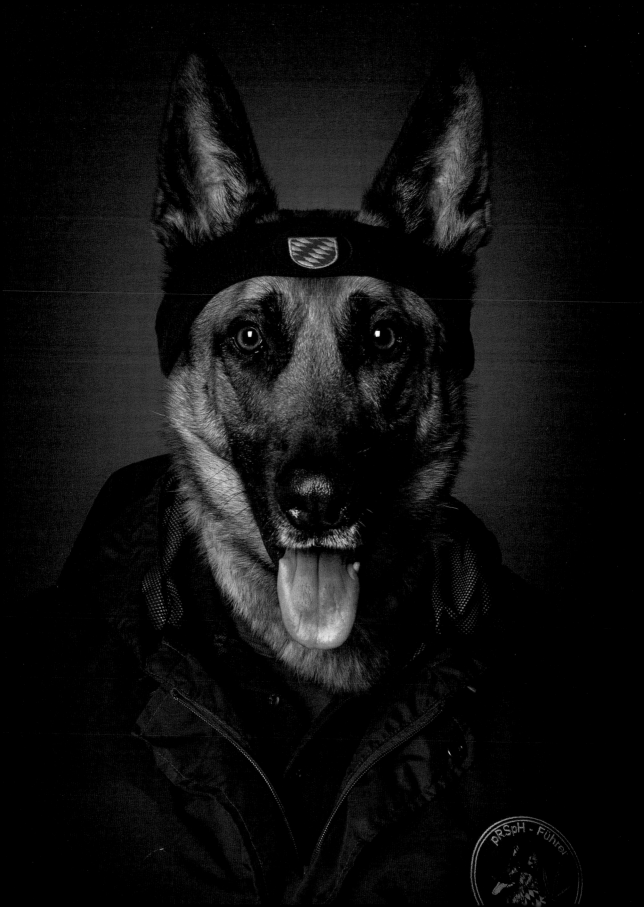

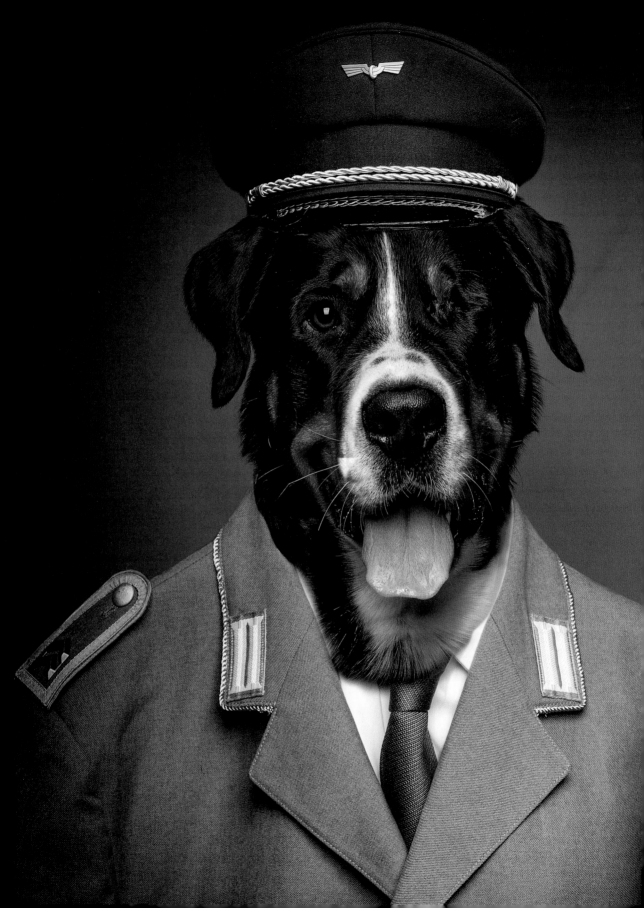

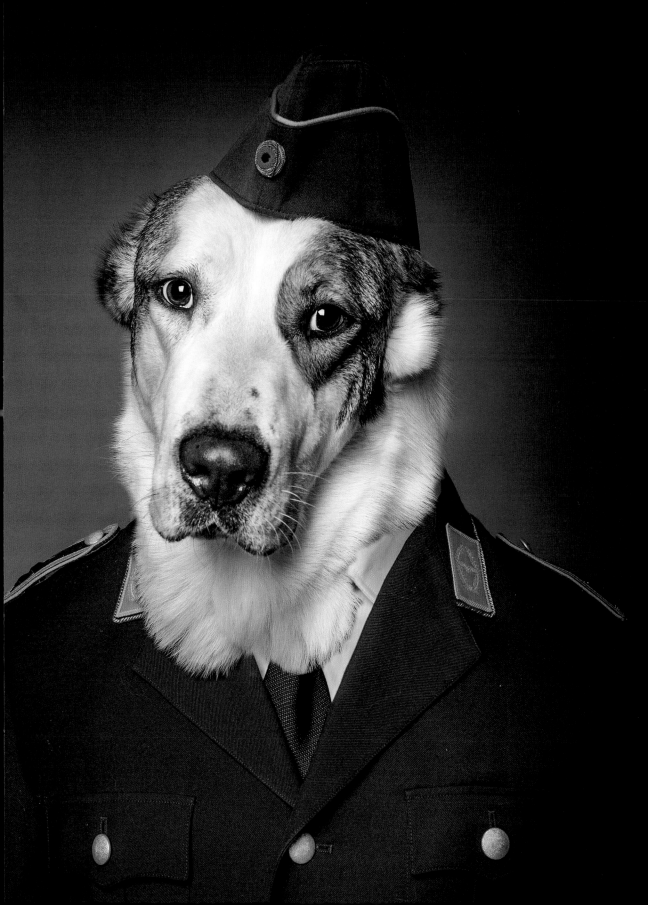

MILOW & BOMBER

Previous page

If Milow and Bomber were human... they would be battle-tested soldiers. And this time it's not just a funny story. Milow has only one eye, and Bomber doesn't have any ears. Bernese Mountain Dog Milow actually injured his own eye in a moment of extreme clumsiness, but herding/guarding dog mix Bomber has unfortunately suffered horrible abuse in his short canine life. Whether it's human or canine life, it's not always funny. And that's why I consciously chose to use real uniforms instead of Halloween costumes.

Wenn Milow und Bomber Menschen wären... dann wären sie wahrscheinlich kriegserfahrene Soldaten. Und dieses Mal ist es auch keine komische Geschichte. Milow hat nur noch ein Auge und Bomber keine Ohren mehr. Wobei der Schweizer Sennenhund Milow sich durch seine Tollpat-schigkeit das Auge selbst ausgestochen hat, während der Herden-Schutzhund-Mix Bomber in seinem Hundeleben leider schon sehr schlimme Erfahrungen gemacht hat. Ob Menschen- oder Hundeleben, nicht alles ist eben immer nur lustig. Auch deswegen habe ich hier ganz bewusst echte Uniformen verwendet und keine Faschingskostüme.

Si Milow et Bomber étaient des humains... ils seraient probablement des soldats très éprouvés. L'histoire n'est pour cette fois pas très drôle car Milow n'a plus qu'un œil et Bomber n'a plus d'oreilles. Cela dit, c'est Milow lui-même qui par sa maladresse s'est éborgné alors que le pauvre Bomber a malheureusement été confronté à de très mauvaises expériences dans sa vie de chien. Humain ou animal, la vie est parfois une drôle de chienne. C'est pourquoi j'ai eu ici recours à de véritables uniformes et non à des costumes de carnaval.

RYUU & NANA

Next page

If Ryuu and Nana were human... they'd probably be married. The Akita Inus love each other in their dog lives as well, but Ryuu could do without all the wedding fiddle-faddle – no matter how lovingly Nana looks at him. All these formalities are just a bore! "Hey Nana, come on, let's elope instead."

Wären Ryuu und Nana Menschen... wären sie wahrscheinlich verheiratet. Die beiden Akita Inus lieben sich auch im Hundeleben, aber Ryuu hätte das ganze Hochzeitsgedöns nicht gebraucht – auch wenn Nana ihn noch so verliebt anschaut. Ist doch langweilig die ganzen Formalitäten. „Hey Nana, komm, wir brennen lieber durch."

Si Ryuu und Nana étaient des humains... ils seraient certainement mariés. Ces deux akitas inus s'aiment profondément (aussi dans leur vie de chien), mais Ryuu aurait bien renoncé à tout le tralala du mariage – même si Nana le regarde avec des yeux langoureux. C'est trop barbant toutes ces formalités. « Eh Nana, arrive, allez, on se tire d'ici ! »

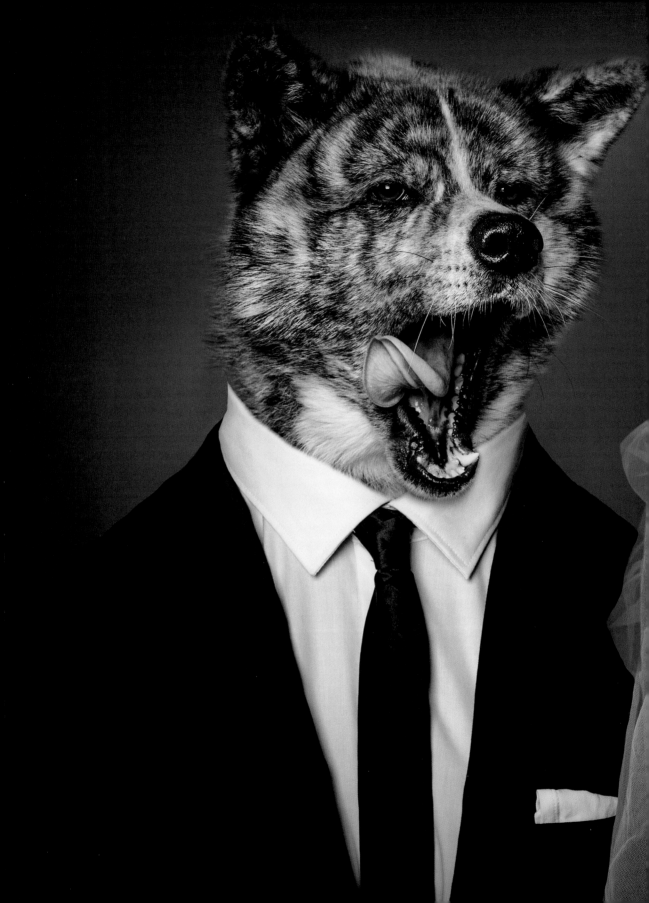

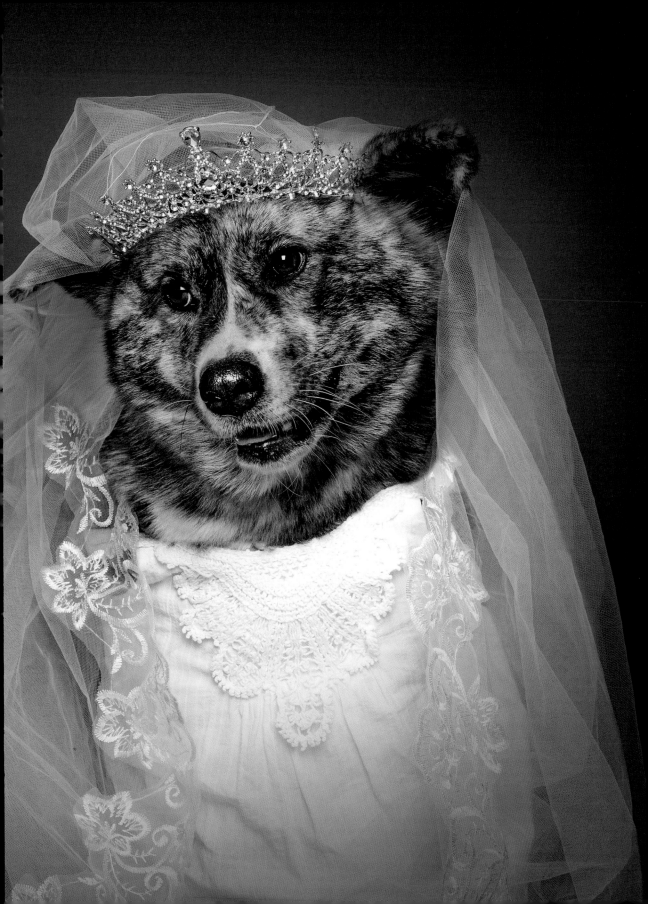

MIRA

If Mira were human... she'd be a grandma who loves to cook. She is a dear, sweet Golden Retriever who loves eating above everything else in the world – which has taken its toll on her waistline over the years. It's a good thing that as a dog, she can't actually reach the stove and cook for herself. "My dears, shouldn't I make you some really splendid chicken soup?"

Wäre Mira ein Mensch... wäre sie eine Oma, die am liebsten kocht. Sie ist eine so liebe und alte Golden-Retriever-Dame, die für ihr Leben gerne isst –, was man mittlerweile auch ein bisschen an ihrer Figur sieht. Gut, dass sie als Hund nicht wirklich selbst an den Herd kann. „Soll ich euch nicht noch so eine richtig gute Hühnersuppe machen, ihr Lieben?"

Si Mira était un humain... elle serait une mamie aimant concocter de bons petits plats. C'est une adorable et vieille dame golden retriever qui n'aime rien autant que manger; en témoigne sa silhouette entre-temps un peu épaissie. Dieu merci, comme chien, elle n'arrive pas à la cuisinière. « Vous ne voulez pas que je vous fasse un petit bouillon de poule, mes chéris ? »

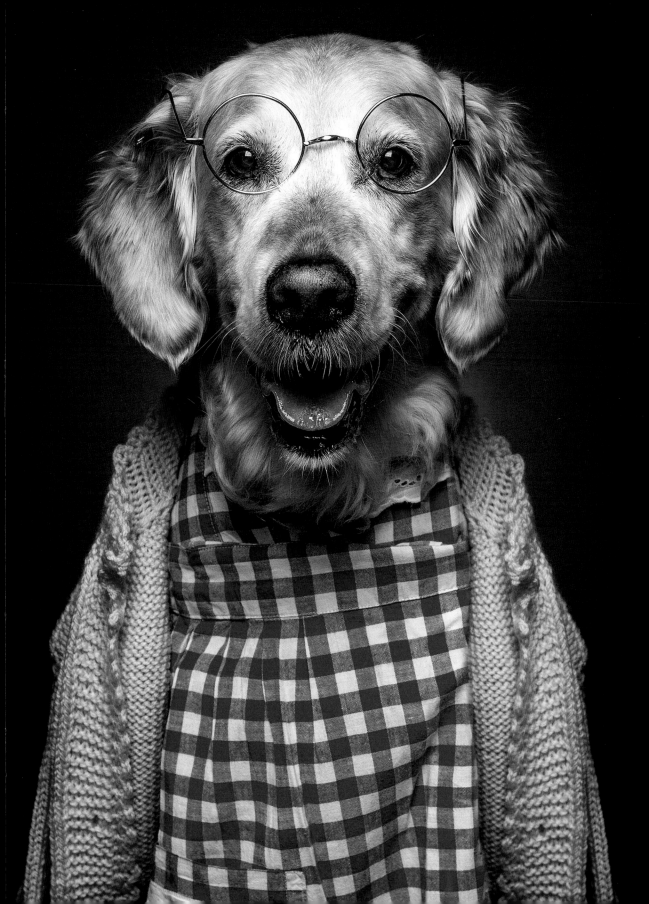

MOLLY

If Molly were human... she'd finally take swimming lessons. The female French Bulldog loves water, but she can't swim! As a person, she would need a life vest. As a dog, she doesn't really care – you just stay away from the deep water, perfectly reasonable, isn't it? "There's just nothing better than a refreshing bath!"

Wäre Molly ein Mensch... würde sie endlich einen Schwimmkurs machen. Denn die Französische-Bulldoggen-Dame liebt zwar Wasser – kann aber nicht schwimmen. Als Mensch würde sie also eine Schwimmweste brauchen. Als Hund ist ihr das ziemlich egal – geht man halt nicht ins tiefe Wasser, ganz logisch, oder? „Es geht einfach nichts über ein erfrischendes Bad!"

Si Molly était un humain... elle s'inscrirait enfin à un cours de natation. Car cette madame bouledogue française, si elle adore l'eau, ne sait pas nager. Comme humain, elle enfilerait simplement un gilet de sauvetage. Comme chien, elle s'en fiche – il suffit de ne pas aller où on n'a pas pied. Logique, non ? « Rien ne vaut un bon bain rafraîchissant ! »

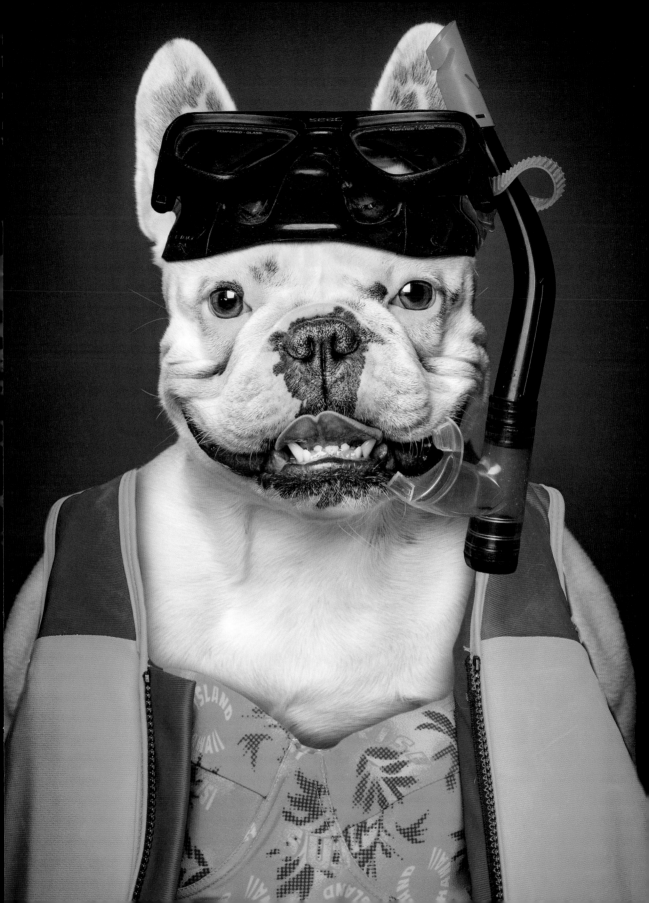

MORITZ VOM FÜRSTENECK

If Moritz were human... he'd definitely be a farmer. The old saying, "If it's unknown to the farmer, it goes uneaten," applies 100% to this male Giant Schnauzer. And for Moritz, it applies not only to food, but to everything he's not already familiar with. Take stairs, for example: after our photoshoot, he absolutely refused to go up the stairs because he doesn't have any at home! I'm sure he was quick to share the story at the local pub over a beer with friends: "So they had some newfangled contraption there that no one in his right mind needs. We have elevators, for heaven's sake!"

Wäre Moritz ein Mensch... wäre er sicher ein Bauer. Denn auf den Riesenschnauzer trifft der Spruch „Was der Bauer nicht kennt, das frisst er nicht" hundertprozentig zu. Und dabei geht es nicht nur ums Fressen, sondern um alles, was er nicht kennt. Treppen zum Beispiel: Nach dem Fotoshooting wollte er partout nicht mehr nach oben gehen, denn Zuhause hat er sowas nicht! Dieses Abenteuer hat er bestimmt beim nächsten Stammtisch im Wirtshaus erzählt. „Also da ham' die so a neumodische Konstruktion – wer braucht denn des?"

Si Moritz était un humain... il serait sûrement paysan. Car ce schnauzer géant illustre parfaitement le proverbe « Prudence est mère de sûreté. » Pas seulement pour la nourriture, mais pour tout ce qu'il ne connaît pas. Les escaliers par exemple : après le shooting photo, notre ami ne voulait absolument pas remonter. Chez lui, il n'y a pas d'escalier ! Nul doute qu'il a raconté son aventure à ses potes du troquet. « Bon dieu, c'est qu'ils ont une espèce de construction moderne – franchement, ça sert-y à quoi tout ça ! »

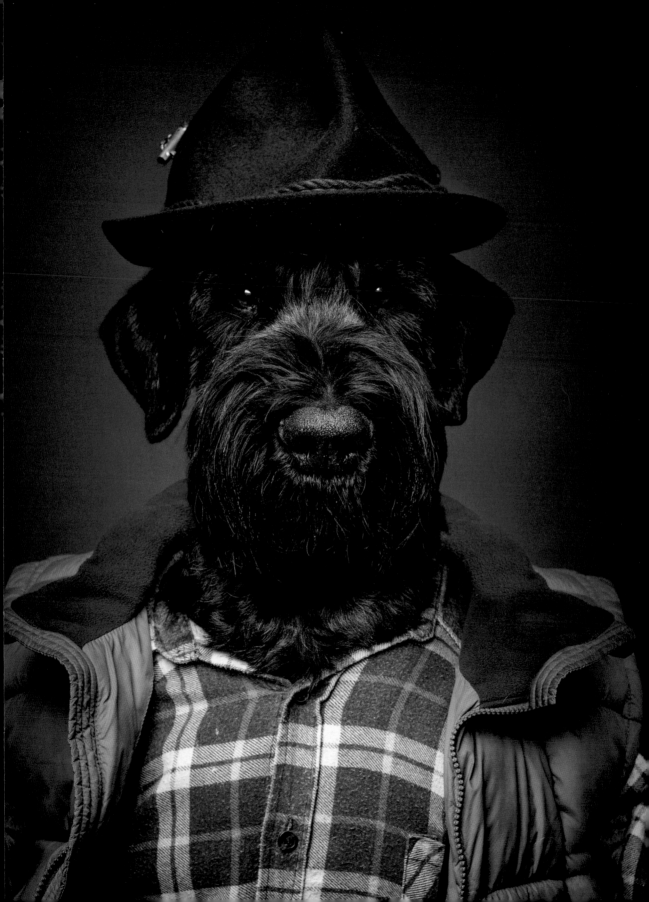

NEEKA

If Neeka were human... she'd be a professional mountain climber. She may be "only" a small, cute Bolonka Zwetna, but she is very athletic and has always loved hiking. She travels three times as far as her owner, and the day always ends too soon. A little dog writ large. "I love the mountains, I love the rolling hills..."

Wäre Neeka ein Mensch... wäre sie professionelle Bergsteigerin. Zwar ist sie „nur" ein kleiner, niedlicher Bolonka Zwetna, aber dafür ist sie sehr sportlich und wandert für ihr Leben gern. Da macht sie dann dreimal die Wege ihrer Besitzer, und der Tag kann gar nicht lange genug sein. Kleiner Hund ganz groß. „Das Wandern ist der Neeka Lust, das Wandern ist der Neeka Lust, das Waaaandern."

Si Neeka était un humain... elle serait alpiniste professionnelle. Si elle n'est qu'un petit bolonka zwetna tout mignon, c'est malgré tout un véritable talent sur le plan sportif et la randonnée, c'est son truc. Elle fait généralement trois fois le trajet de son propriétaire et les journées ne sont jamais assez longues. Petit chien arrivera loin. « Je marche, donc je suis. Un kilomètre à pied, ça use, ça use... »

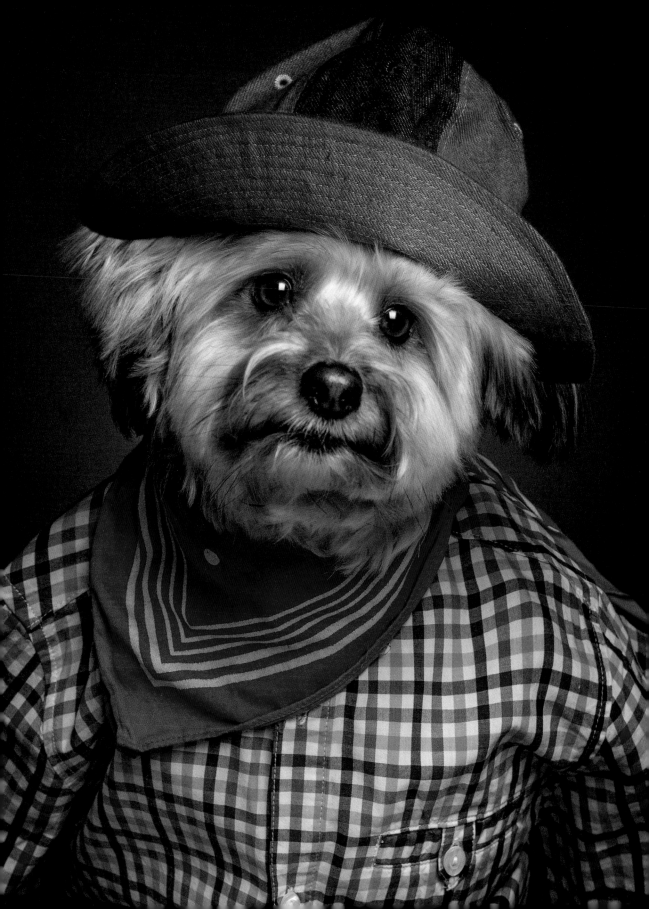

PIPER

If Piper were human... she'd be a bling-bling princess and groupie in Freddie and Little John's gang (page 58/59 and 100/101). The Dogo Argentino mix is really street-smart and pretty confident, but has always been a shameless flirt. Kind of a mix of "Wassup?" and "Heeeey, be nice to me, I'm a girl..."

Wäre Piper ein Mensch... wäre sie eine Bling-Bling-Prinzessin und Groupie der Gang von Freddie und Little John (Seite 58/59 und 100/101). Die Dogo-Argentino-Mix-Hündin ist richtig streetsmart, ziemlich selbstbewusst, flirtet aber auch für ihr Leben gern. So eine Mischung aus „Was geht ab!" und „Hey seid lieb zu mir, ich bin ein Mädchen..."

Si Piper était un humain... elle serait une princesse Bling-Bling et une groupie du gang de Freddie et Little John (pages 58/59 et 100/101). Cette chienne croisée dogue argentin, très sûre d'elle, se sent dans la rue dans son élément et flirte très volontiers. Un mélange de « Quoi de neuf, les gars? » et « Vous êtes sympas avec moi, je suis une fille quoi... »

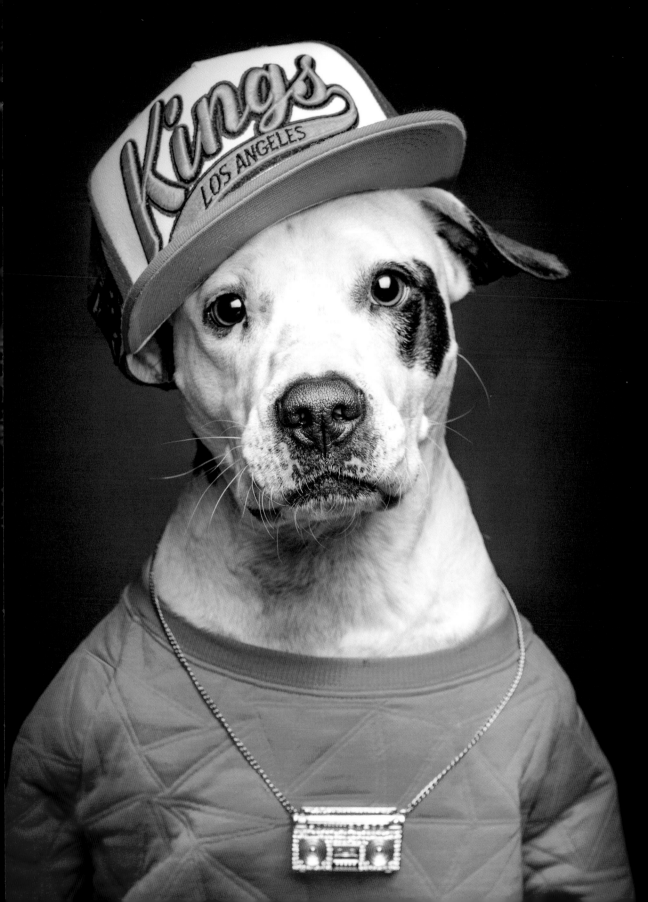

ELLA MAFALDA VON DER STADENSTRASSE

If Ella were human... she might be a rock princess. Admittedly, she doesn't have a classic princess face and has more of a resemblance to a chubby fairy, but the female English Bulldog has the sensitive soul of a princess. She was so excited during her photoshoot that she kept offering me her paw. Actually, we should set her up with Gismo (page 70/71). Then the two of them could zoom off together into the sunset on their motorcycle.

Wäre Ella ein Mensch... wäre sie vielleicht eine Rocker-prinzessin. Zugegebenermaßen hat sie kein klassisches Prinzessinnengesicht und sieht eher ein bisschen aus wie eine Pummelfee. Aber dafür hat die Englische-Bulldo-gen-Dame ein zartes Seelchen. Beim Fotoshooting war sie so aufgeregt, dass sie immer Pfötchen gegeben hat. Eigentlich müsste man sie mit Gismo (Seite 70/71) verkup-peln. Dann könnten die beiden auf ihrem Motorrad in den Sonnenuntergang brausen.

Si Ella était un humain... elle serait peut-être une prin-cesse de rock. Bon d'accord, elle n'a pas le visage classique d'une princesse et ressemble plutôt un peu à une fée bou-lotte. Pour le reste, cette dame bouledogue anglais a l'âme tendre d'une petite princesse. Pendant la séance photo, elle était tellement énervée qu'elle n'a cessé de donner la patte. En fait, il faudrait lui présenter Gismo (page 70/71). Je les vois bien tous les deux caracoler sur leur moto dans la lumière du soleil couchant.

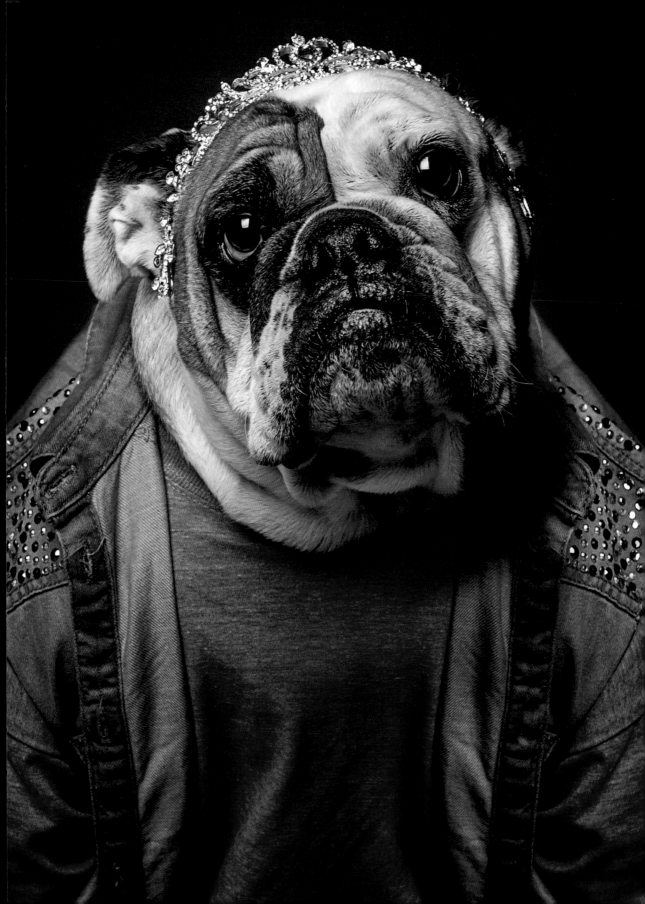

ROCKY

If Rocky were human... he'd be an ideal football player. The purebred registered American Staffordshire Blue Line from Baden-Wuerttemberg is an impressive sight with his bull-like head and a body that is all muscle. An opponent would have a tough time getting past him. But Rocky always displays great sportsmanship, and he is totally friendly to other dogs and people. "Hut! Just kidding! I just want to play!"

Wäre Rocky ein Mensch... wäre er ein idealer Football-spieler. Der reinrassige und ordentlich gemeldete American Staffordshire Blue Line aus Baden-Württemberg ist schon eine beeindruckende Erscheinung mit seinem bulligen Kopf und dem Körper, der nur aus Muskeln besteht. Da kommt so schnell kein Gegner vorbei. Aber Rocky bleibt immer fair, er ist absolut freundlich mit anderen Hunden und Menschen. „Huh! – nur ein Scherz! Ich will nur spielen!"

Si Rocky était un humain... il serait dans tous les cas un rugbyman idéal. Ce terrier de pure race American Staffordshire Blue Line, dûment enregistré, vit dans le Bade-Wurtemberg. C'est un chien assez imposant avec sa large tête et son corps particulièrement musculeux. Gare aux adversaires qui ne passeront pas facilement. Mais Rocky ne cherche pas la bagarre et se montre plutôt sympa avec les autres chiens et les humains. « Cool Raoul, c'était juste une blague ! Je veux juste jouer ! »

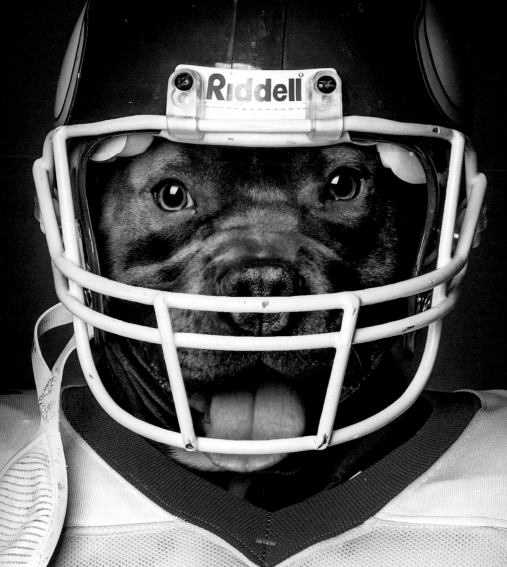

ROXY

If Roxy were human... she'd love to be an actress. Here, she's playing the role of cool Roxy in a street musical. She absolutely loved being the center of attention during her photoshoot – I think we could have tried out twenty more costumes on her. But she has also been through some bad experiences. Her first owners neglected her, so perhaps that's why she enjoys it so much when all eyes are on her. "So hey, if you want to see a different pose, just say the word... "

Wäre Roxy ein Mensch... wäre sie bestimmt gerne Schauspielerin, hier in der Rolle der coolen Roxy aus dem Street-Musical. Sie hat es so genossen beim Fotoshooting im Mittelpunkt zu stehen – ich glaube, wir hätten noch zwanzig Kostüme mit ihr ausprobieren können. Aber sie hat auch schon schlechte Erfahrungen hinter sich: Von ihren ersten Besitzern wurde sie ziemlich vernachlässigt. Vielleicht genießt sie es auch deshalb so, wenn jeder auf sie schaut. „Also wenn ich noch 'ne andere Pose zeigen soll, müsst ihr es nur sagen... "

Si Roxy était un humain... elle aimerait certainement devenir actrice. Ici, dans le rôle de Roxy maxi cool dans la comédie musicale de rue. Elle a manifestement savouré d'être au centre de l'attention pendant le shooting photo – je crois bien qu'on aurait pu lui faire encore essayer vingt autres costumes. Mais elle a aussi connu de mauvaises expériences et a été négligée par ses premiers maîtres. C'est peut-être la raison pour laquelle elle apprécie qu'on s'intéresse à elle. « Voulez-vous que je prenne une autre pose ? Pas de souci, il suffit de le dire... »

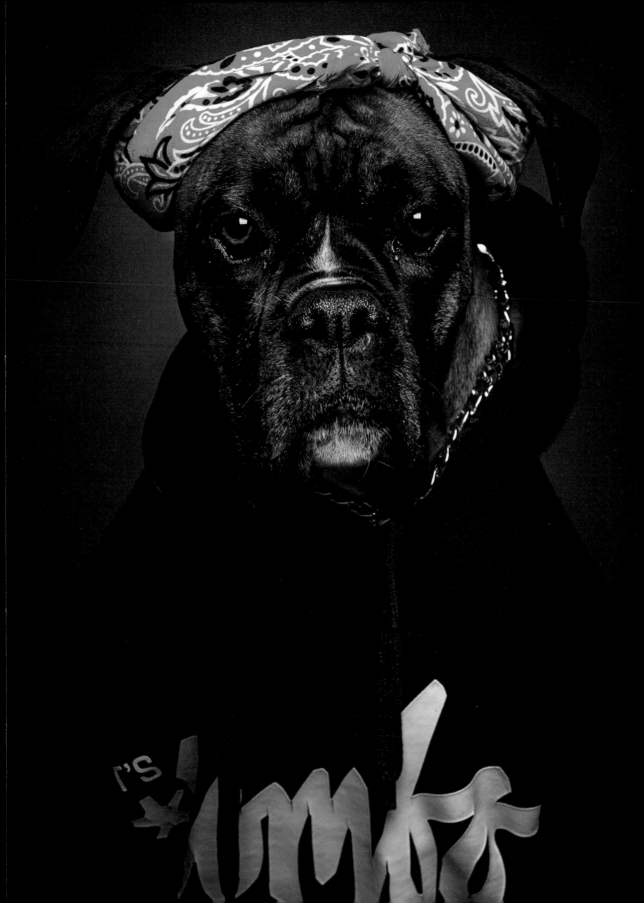

FRIEDA
(ROYAL SUNFLOWER)

If Frieda were human... she would be just as noble as her kennel name. Her owner described her English Cocker Spaniel with the following sentence: "She has mastered the art of royal elegance, including the art of feigning ignorance." I got to experience that firsthand. Like all Cockers, she is sweet and playful and actually quite well-behaved. But if she doesn't want to hear something, her reaction is: "Did someone say something to me? I didn't hear a thing."

Wäre Frieda ein Mensch... wäre sie definitiv so adlig wie ihr Zuchtname. Ihre Besitzerin hat mir ihren English Cocker Spaniel mit folgendem Satz beschrieben: „Sie beherrscht die royale Eleganz bis hin zur Ignoranz." Das habe ich dann auch erlebt. Sie ist, wie alle Cocker, natürlich lieb und verspielt und eigentlich auch gut erzogen. Aber wenn sie etwas nicht hören will: „Hat da irgendjemand was zu mir gesagt – also, ich hab nichts gehört."

Si Frieda était un humain... elle serait à coup sûr aussi noble que le nom de son élevage. Sa propriétaire m'a décrit sa chienne de race cocker spaniel anglais ainsi : « Elle maîtrise l'élégance royale de A à Z jusqu'à l'ignorance. » C'est bien ce que j'ai constaté. Comme tous les cockers, elle est attachante et enjouée et puis, bien élevée. Mais quand elle ne veut pas entendre quelque chose : « On m'a parlé ? Personnellement, je n'ai rien entendu. »

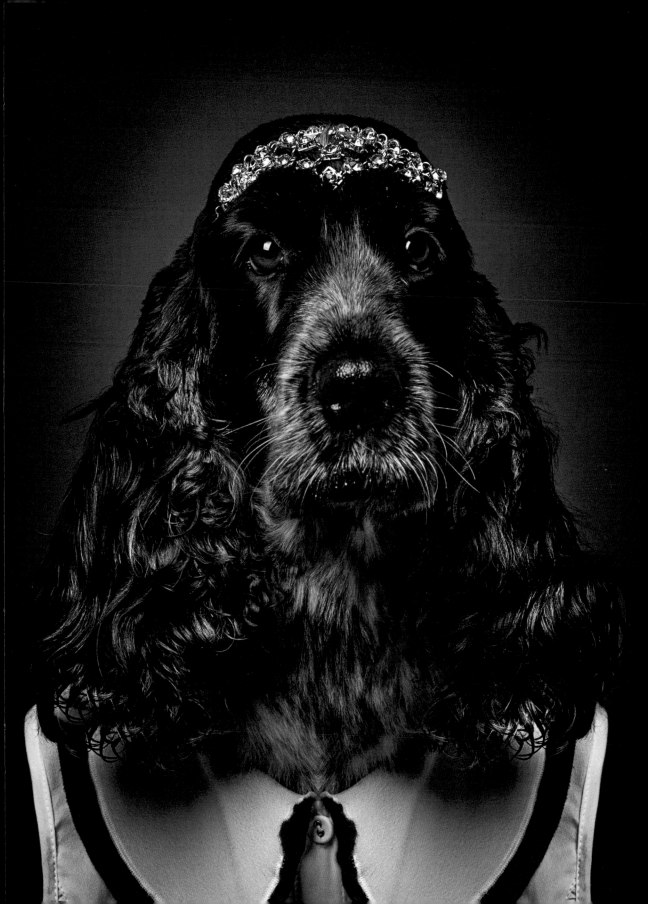

SALLY

If Sally were human... she'd be a tennis player. The moment the female Goldendoodle sees a tennis ball, she forgets everything else around her. "Ha, if I could only manage to hold the stupid racket, I'd have long since become the top-ranked player in the world!"

Wäre Sally ein Mensch... wäre sie Tennisspielerin. Denn wenn die Goldendoodle-Dame einen Tennisball sieht, dann ist alles um sie herum vergessen. „Ha, wenn ich nur den blöden Schläger halten könnte, wäre ich schon längst die Nummer 1 der Weltrangliste."

Si Sally était un humain... elle serait joueuse de tennis. Car dès que cette chienne golden Doodle aperçoit une balle de tennis, elle oublie le monde autour d'elle. « Si seulement je pouvais tenir cette stupide raquette, il y a longtemps que je serais le numéro 1 mondial. »

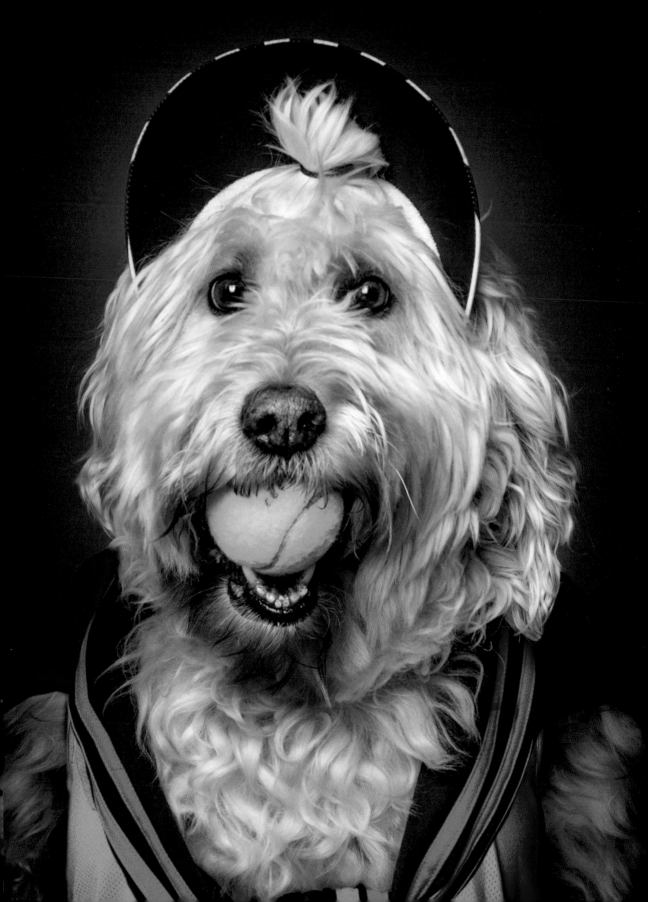

SCULLY

If Scully were human... she'd be a rebellious teenager. Only they have the power to roll their eyes with such exasperation. The owner of the female Alaskan Husky with the differently colored eyes had already told me that Scully was a "cool cat and a little rebel." I noticed that at her photoshoot. When it was her turn to sit for three minutes, she clearly did not like the idea at first. She just didn't feel like it. "All right, all right, we can do the session. But hurry up and get this over with!"

Wäre Scully ein Mensch... wäre sie ein rebellischer Teenager. Nur die können die Augen so genervt verdrehen. Die Besitzerin der Alaskan-Husky-Hündin mit den zweifarbigen Augen hatte mir schon gesagt, dass Scully eine „coole Socke und eine kleine Rebellin" sei. Das hat man auch beim Shooting gemerkt. Als sie sich für ihre drei Minuten hinsetzen sollte, hat ihr das offensichtlich erst mal nicht gepasst. Sie hatte einfach keinen Bock. „Ja, OK, machen wir die Session. Aber dann mach mal hinne damit."

Si Scully était un humain... elle serait un adolescent rebelle. Il n'y a qu'eux pour savoir aussi bien lever les yeux au ciel. La propriétaire de cette chienne Alaskan Husky avec les yeux vairons m'avait prévenue d'emblée que Scully est une « chouette copine et une petite rebelle. » C'est bien ce qu'on a vu pendant la séance. Lorsqu'il a fallu qu'elle s'asseye pour trois minutes, ça ne lui a manifestement pas convenu. Elle n'avait simplement pas envie. « Bon d'accord, on se fait la session. Allez, magne-toi ! »

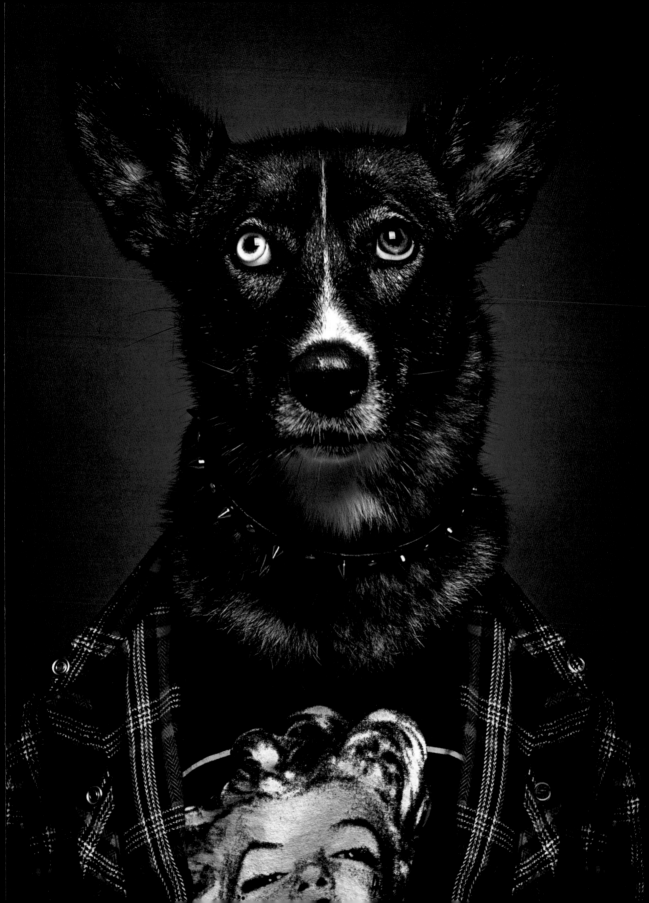

SUNDAY

If Sunday were human... she'd be a singer for sure. After all, she can see from her owner's singing career what a great job it is. However, after the first few test shots, the female husky mix apparently decided to switch to being a DJ instead. It's cool too, and you only need a good mood instead of a good voice. "But music is totally my life, for sure."

Wäre Sunday ein Mensch... wäre sie sicher Sängerin. Denn bei ihrer singenden Besitzerin sieht sie ja, wie wunderschön dieser Beruf ist. Obwohl – nach den ersten Probeaufnahmen hat sich die Husky-Mix-Dame schon überlegt, ob sie lieber auf DJ wechseln sollte. Ist auch cool, und man ist nur auf gute Stimmung statt auf eine gute Stimme angewiesen. „Aber Musik ist auf alle Fälle voll mein Leben."

Si Sunday était un humain... elle serait certainement chanteuse. Car elle a pu constater chez sa propriétaire que cette profession est formidable. Pourtant, après les premiers enregistrements, la chienne croisée husky a hésité si elle ne devait pas plutôt se diriger vers une carrière de DJ. C'est aussi cool et on n'est pas dépendant de sa voix. « En tout cas, la musique, c'est toute ma vie. »

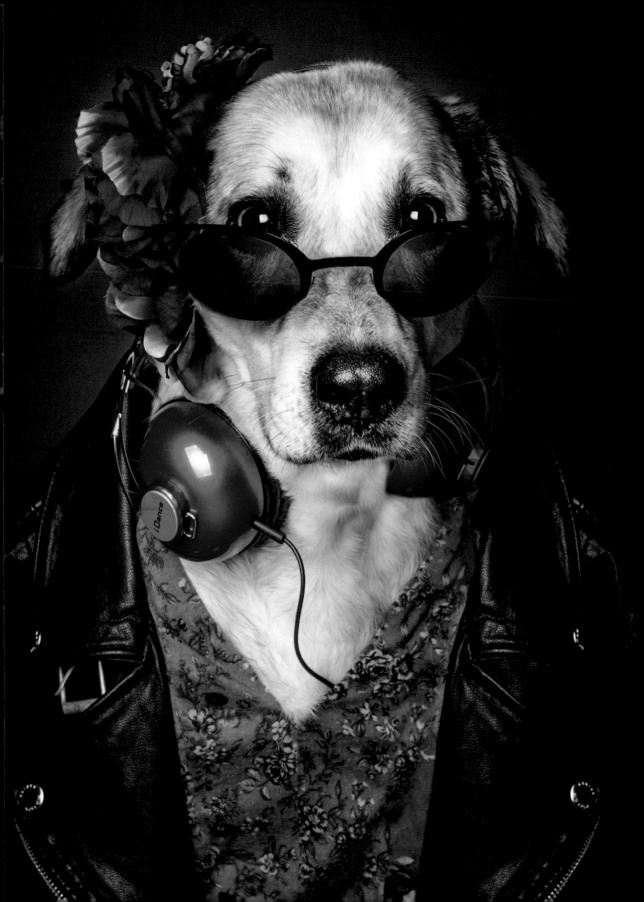

TAMINA SWEET EMOTIONS

If Tamina were human... she'd be a passionate skier. From a fashion standpoint, she's still a bit stuck in the 80s, has been on the slopes for 40 years, and still drinks a Jägertee before her last run down the hill. And what's really important: dressing warmly, and sure, she'll cuddle a little. "I mean, the après-ski is part of the experience."

Wäre Tamina ein Mensch... wäre sie passionierte Skifahrerin. Modisch noch ein bisschen in den 80er-Jahren stecken geblieben, seit 40 Jahren auf der Piste und vor der letzten Abfahrt noch ein Jagertee. Und ganz wichtig: immer warm angezogen und gerne ein bisschen kuscheln. „Also das Après-Ski gehört halt schon dazu."

Si Tamina était un humain... elle serait une férue de ski. En matière de mode, elle en est restée aux années 80, mais dévale les pistes depuis 40 ans et, avant la dernière descente, s'offre un thé au rhum. Très important : s'habiller chaudement et ne pas lésiner sur les câlins. « Évidemment, l'après-ski, ça fait partie du jeu. »

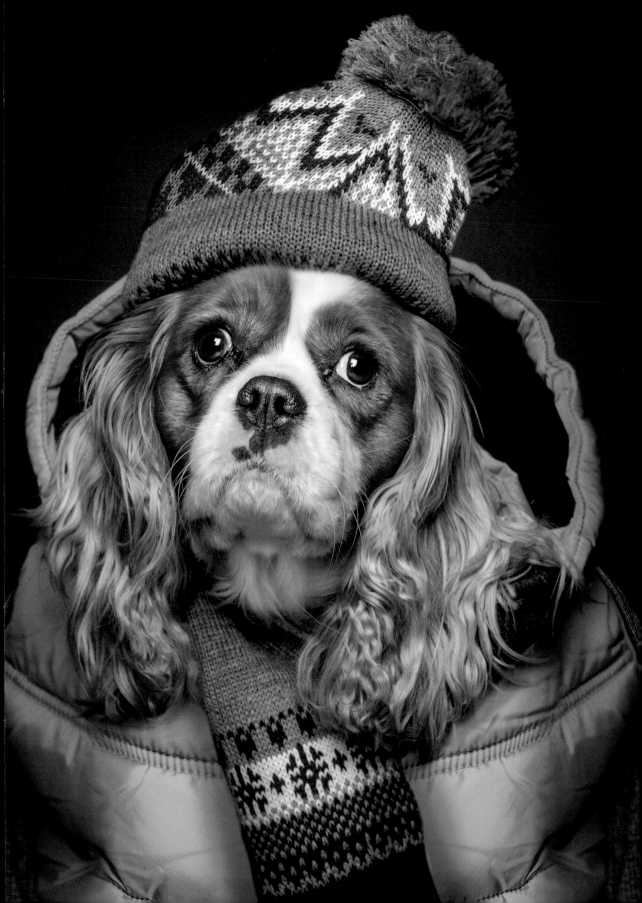

WED TAMRIT'N SHAT-EHAD

If Tamrit were human... she'd be an Olympic gold medalist in the 100-meter dash and run marathons. The female Azawakh leaves my Maja (page 110/111) in the dust when they play together – which Maja acknowledges by laying down and waiting until Tamrit races by again. But with the earbuds and headband, she really does look like an older marathoner who is wiry and lean and has been running throughout her life.

Wäre Tamrit ein Mensch... wäre sie Olympiasiegerin im 100-Meter-Sprint und Marathonläuferin. Die afrikanische Windhündin lässt meine Maja (Seite 110/111) beim Spielen weit hinter sich – was Maja damit quittiert, dass sie sich einfach hinlegt und wartet, bis Tamrit wieder vorbeikommt. Aber mit den Kopfhörern und dem Stirnband sieht Tamrit doch auch wirklich so aus wie eine ältere Marathonläuferin, die so richtig drahtig ist und schon ihr ganzes Leben immer nur rennt.

Si Tamrit était un humain... elle serait championne olympique à l'épreuve du 100 m et coureuse de marathon. Ce lévrier africain laisse loin derrière ma chienne Maja (page 110/111) dès qu'elles commencent à jouer – Maja réagit en s'allongeant simplement et attend que sa camarade revienne par là. Avec les écouteurs et le bandeau, Tamrit a vraiment l'air d'une coureuse de marathon confirmée et très endurante, genre qui court depuis des années et des années.

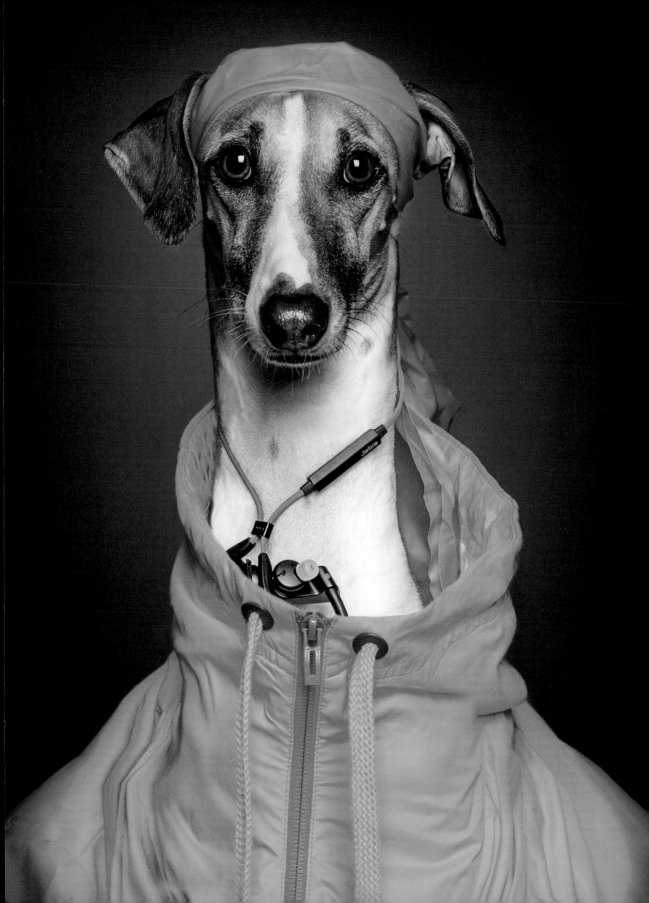

VANESSA VOM SCHREBERGARTEN

If Vanessa were human... she could be a firefighter. The female Great Dane is very large and powerful, always keeps her cool, and enjoys taking on a leadership role when she plays with others. So she'd be perfect with the fire department, where she'd always keep an eye on everything, coordinate her team calmly, and then put her plan into action: "Everyone, move at my command – and I don't want to see anyone upsetting the apple cart here! Water on!"

Wäre Vanessa ein Mensch... könnte sie eine Feuerwehrfrau sein. Die Doggen-Dame ist sehr groß und kraftvoll, bewahrt stets die Ruhe und übernimmt im Spiel mit anderen gerne auch mal die Führung. Also wäre sie doch perfekt bei der Feuerwehr, wo sie alles im Blick behält, in Ruhe koordiniert und dann geplant eingreift. „Alles hört auf mein Kommando –, und dass hier keiner aus der Reihe tanzt! Wasser marsch!"

Si Vanessa était un humain... elle pourrait être pompier. La femelle dogue est très grande et puissante, ne se départit jamais de son calme et, dans ses jeux avec les autres, aime bien prendre les choses en main. Nul doute qu'elle serait parfaite dans l'équipe de pompiers : ne perd pas le nord, coordonne calmement et ses interventions sont bien calculées. « On obéit aux ordres – personne ne fait cavalier seul. Ouvrez l'eau ! »

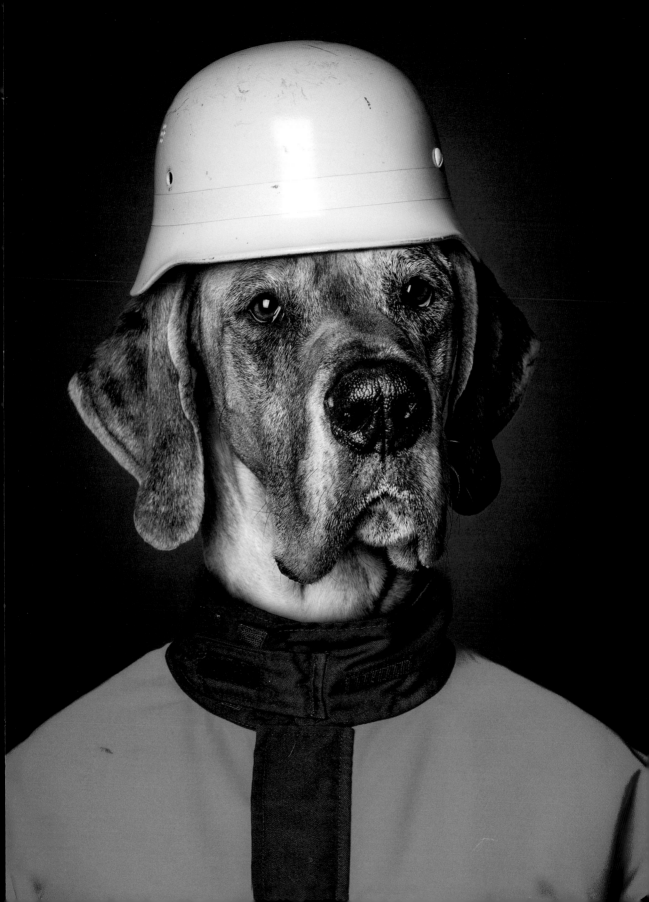

WILLI

If Willi were human... he'd be a huntsman. That would allow him to combine his two great passions: his prey drive and his love for the horses in his owner's stables. And the male Jack Russell mix thinks the fact that you look so posh while doing it isn't bad either. "Halloo!"

Wäre Willi ein Mensch... wäre er Jagdreiter. Da könnte er seine beiden großen Leidenschaften verbinden: seinen Jagdtrieb und die Liebe zu den Pferden im Reitstall seiner Besitzerin. Und dass man dabei so fesch aussieht, findet der Jack-Russell-Mix-Rüde auch gar nicht schlecht. „Horrido!"

Si Willy était un humain... il serait veneur. Ce qui lui permettrait de combiner ses deux plus grandes passions : son instinct de chasseur et son amour des chevaux au centre d'équitation de sa propriétaire. Et puis, cette élégance et cette classe ne sont pas pour déplaire à Willi, croisé Jack Russell. « Taïaut ! »

WOODY

If Woody were human... he'd definitely be a chef. This would enable him to ensure that he is always as close as possible to the thing that gives his life meaning: something to eat! Yes, this makes Woody a very typical beagle. I think a pack of beagles would actually be a perfect kitchen crew. The only question would be whether the guests would get to eat anything. "Bon appetit... to me!"

Wäre Woody ein Mensch... wäre er ganz sicher Koch. Denn so könnte er sicherstellen, dass er seinem Lebensinhalt immer ganz nahe ist: Irgendwas zu essen! Ja, damit ist Woody ein ganz typischer Beagle. Ich glaube, ein Beagle-Rudel wäre auch eine perfekte Küchencrew. Fragt sich nur, ob die Gäste auch noch etwas zu essen bekämen. „Ich lass es mir schmecken!"

Si Woody était un humain... il serait certainement cuisinier. Car ce serait un moyen sûr de rester à proximité immédiate de sa principale priorité dans la vie : manger ! Woody est donc un beagle typique. Et je crois sincèrement qu'une meute de beagles constituerait une formidable équipe en cuisine. Reste à savoir si les hôtes finiraient pas avoir quelque chose à manger. « Je goûte seulement ! »

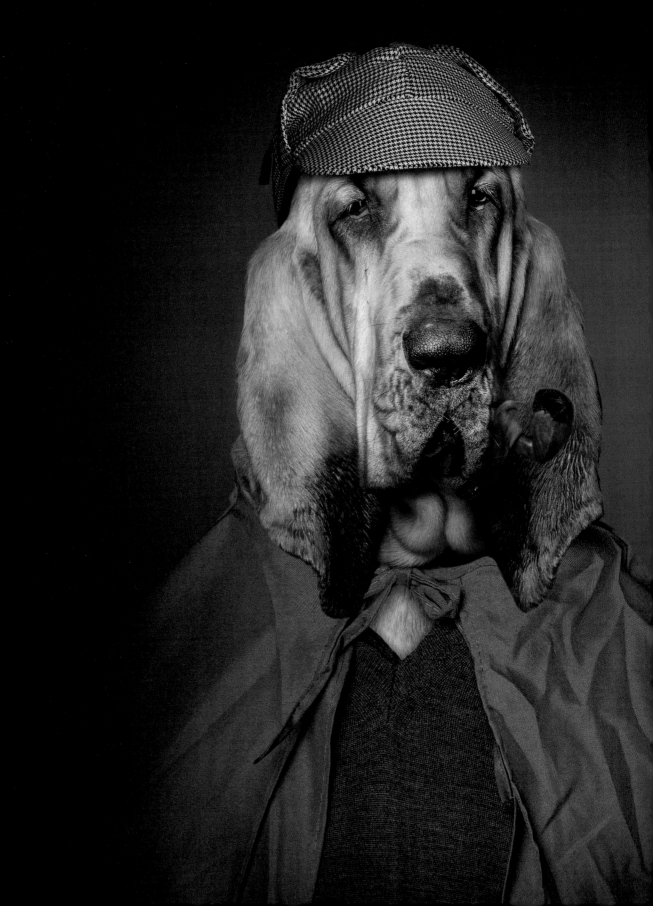

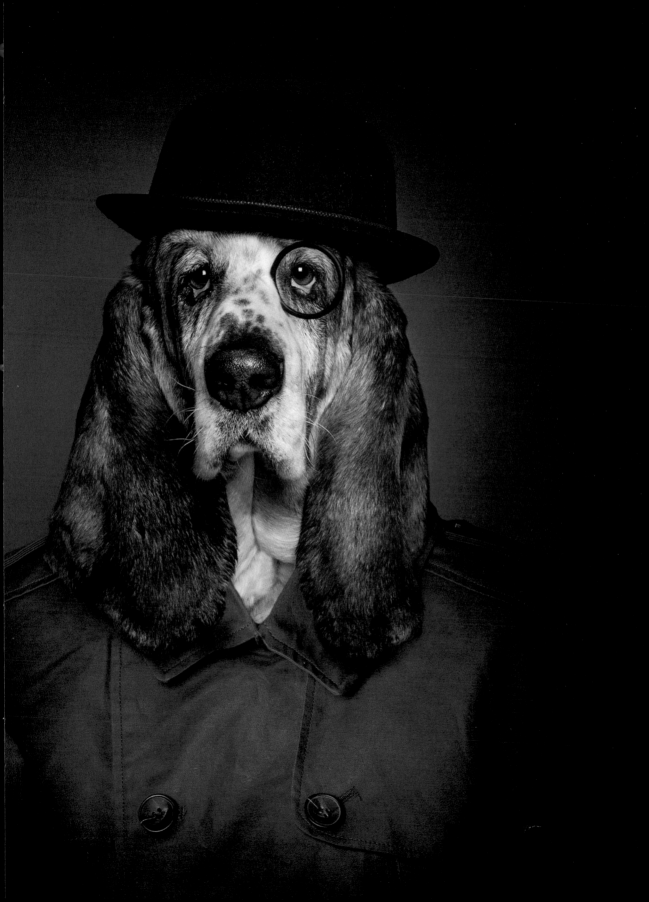

HILDE & COLUMBO
(FIRST AGENT COLUMBO OF MAIN BRIDGE)

Previous page

If Hilde and Columbo were human... they would be detectives – they just wouldn't be able to agree on who is Sherlock Holmes and who is Dr. Watson. Both are already tracking dogs; one is a Bloodhound, and the other is a Basset Hound. But they don't yet have their licenses and are dependent on their owners' supervision, despite the fact that the humans are much dumber. "Come on, Hilde, we'll solve the case ourselves."

Wären Hilde und Columbo Menschen... wären sie Detektive – sie könnten sich nur nicht einigen, wer Sherlock Holmes und wer Dr. Watson ist. Beide sind schon als Hunde Spurensucher, die eine als Bloodhound, der andere als Basset Hound. Aber sie haben eben noch keine Lizenz und sind auf die Aufsicht ihrer Herrchen angewiesen. Dabei sind die doch viel dümmer. „Los Hilde, wir lösen den Fall alleine."

Si Hilde et Columbo étaient des humains... ils seraient détectives – mais n'arriveraient pas à décider lequel est Sherlock Holmes et lequel Watson. Limier et basset sont tous deux excellents dans la recherche de traces. Seul hic : ils n'ont pas encore de licence et sont donc dépendants de la surveillance de leurs maîtres. Qui sont bien moins doués. « Viens donc Hilde, on va résoudre le cas tout seuls. »

MÖHRE & DORI

Next page

If Möhre and Dori were human... they'd probably be true rockabilly fans. The motto of Boxer-Labrador mix Möhre and female Parson Russell Terrier Dori is "Rock around the clock." It is simply not possible to wear these two out! The only amazing thing was that they both managed to hold still at the same time for their photo. "See you later, alligator!"

Wären Möhre und Dori Menschen... wären sie wahrscheinlich echte Rockabilly-Fans. Beim Boxer-Labrador-Mix Möhre und der Parson-Jack-Russell-Hündin Dori heißt es „Rock around the clock." Die beiden sind einfach nicht müde zu bekommen. Erstaunlich war nur, dass sie tatsächlich fürs Foto beide gleichzeitig stillgehalten haben. „See you later alligator."

Si Möhre et Dori étaient des humains... ils seraient probablement de vrais fans de rockabilly. Pour Möhre, un labrador croisé boxer, et Dori, une Parson-Jack-Russel, c'est toute la sainte journée « Rock around the clock. » Jamais fatigués. Le plus étonnant est qu'ils sont vraiment restés tranquilles le temps de la photo. « See you later alligator. »

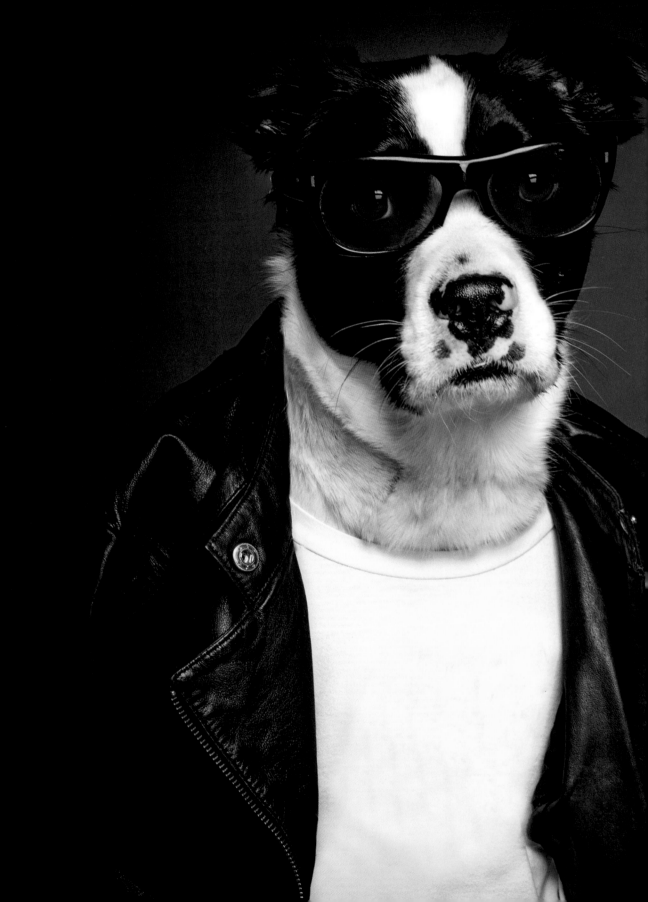

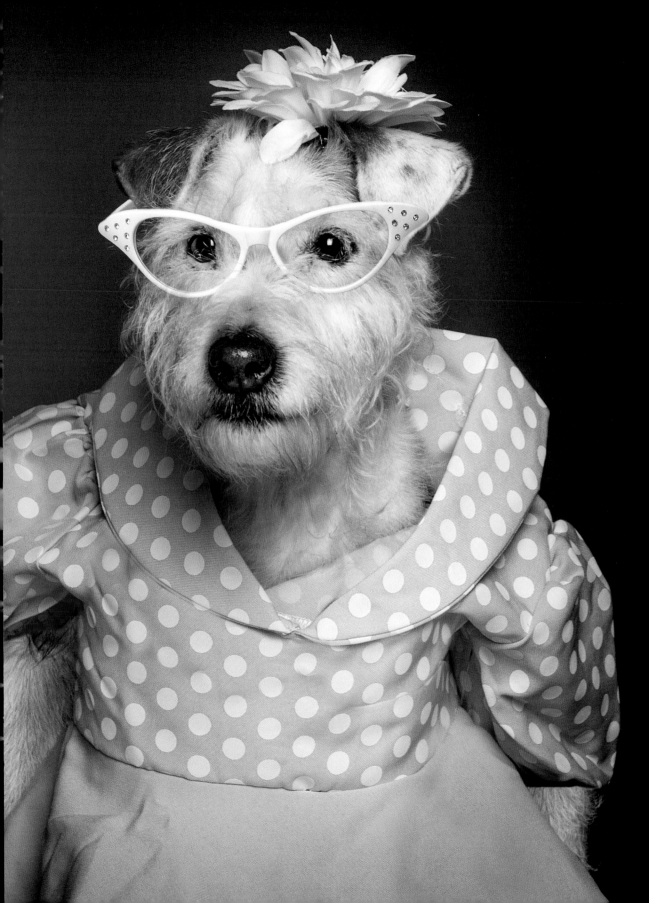

AKITA

If Akita were human... she'd be a wannabe It Girl, because Madame Akita is the teensiest bit conceited. When the female Akita Inu doesn't like something, she simply turns her back on it – photoshoots included. Only once we had all assured her how unbelievably pretty she is did she deign to turn graciously toward us. "Well, a photo of me can only turn out one way: great!"

Wäre Akita ein Mensch... wäre sie sicher ein Wanna-be-It-Girl. Denn Madame Akita ist ein ganz kleines bisschen eingebildet. Wenn der Akita-Inu-Dame irgendwas nicht passt, dreht sie sich einfach um – so auch beim Fotoshooting. Erst, als wir ihr alle bestätigt haben, wie wahnsinnig hübsch sie sei, hat sie sich uns huldvoll zugewandt. „Naja, ein Foto mit mir kann ja nur gut werden."

Si Akita était un humain... elle serait certainement une It-Girl du groupe Wannabe. Car elle fait un peu dans le genre présomptueux. Lorsque quelque chose ne convient pas à Dame Akita-Inu, elle se détourne – cela a été le cas pendant le shooting. Ce n'est qu'après que tout le monde lui a assuré qu'elle était très très belle qu'elle nous a gracieusement accordé son attention. « Bon d'accord, une photo de moi ne fera pas de mal. »

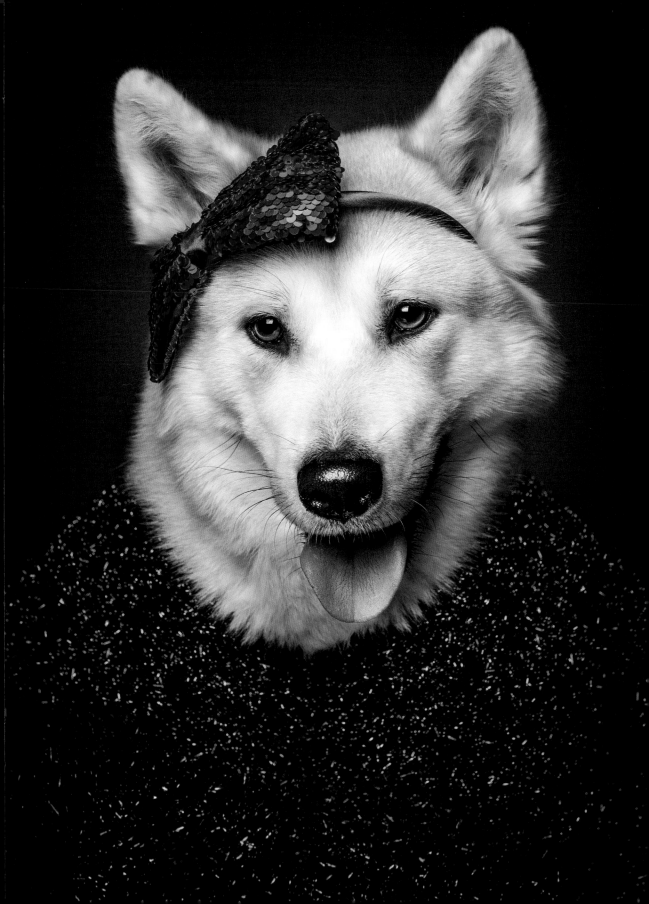

GISMO

If Gismo were human... he'd clearly be a Mexican. After all, Chihuahuas come from Mexico, and Gismo has the temperament to match. Oh, you don't think this looks like temperament? That's probably because I could see what a hard time he had staying still for just two minutes for his photoshoot. "Hi chicas, keep going, I just have to sweeng my sombrero again real queeck. Ees very boring here."

Wäre Gismo ein Mensch... wäre er ganz klar Mexikaner. Schließlich kommen Chihuahuas aus Mexiko. Und Gismo hat auch das entsprechende Temperament. Das sieht hier gar nicht nach Temperament aus? Liegt wahrscheinlich daran, dass es ihm sichtlich schwergefallen ist, auch nur zwei Minuten fürs Fotoshooting still zu halten: „Hola Chicas, macht mal weiter, ich musse snell wieder meine Sombrero swenken. Isse sehr langweilig hier."

Si Gismo était un humain... il serait évidemment Mexicain. En plus, les chihuahuas sont vraiment originaires du Mexique. Et Gismo a le tempérament qui va avec. Il n'a pas l'air comme ça ? C'est sûrement dû au fait qu'il a vraiment eu du mal à rester tranquille pendant les deux minutes où j'ai pris mes photos. « Holla Chicas, continuez, continuez, faut que je rajuste mon sombrero, là. Mais qu'est-ce qu'on se barbe ici... »

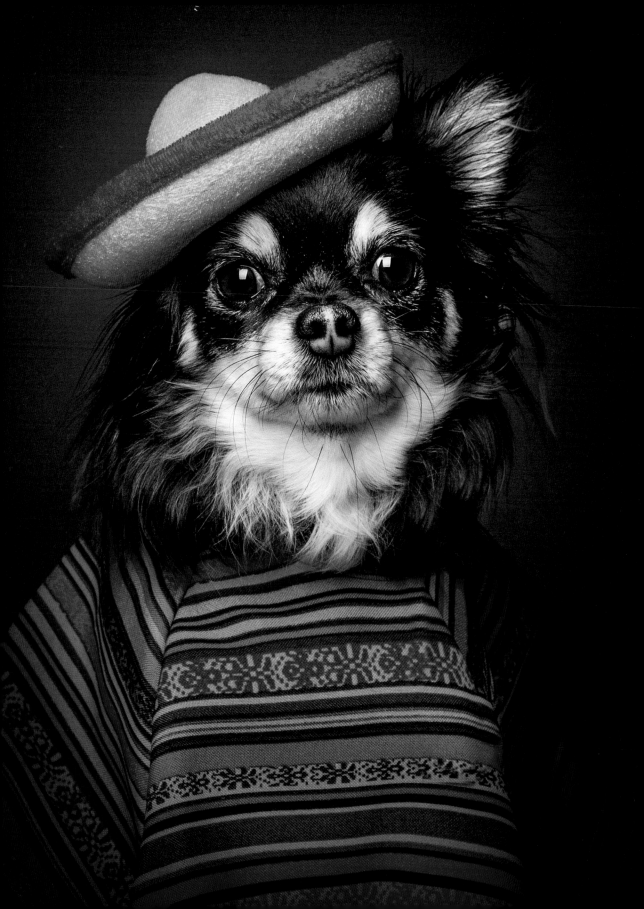

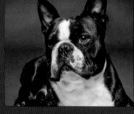

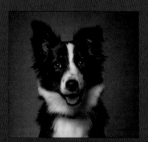
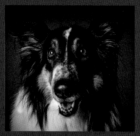
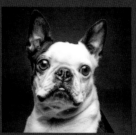
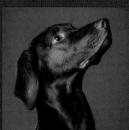
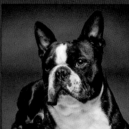

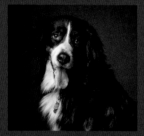
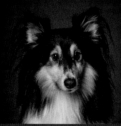

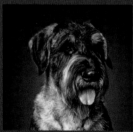

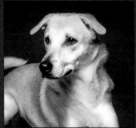

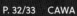

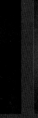
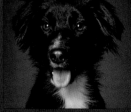
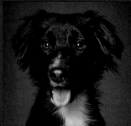

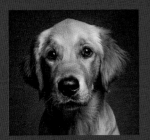
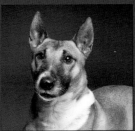
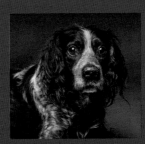
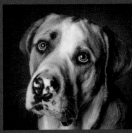

MILA P. 40/41 CRAZY P. 42/43 DIEGO P. 44/45 DJANGO P. 46/47

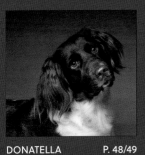

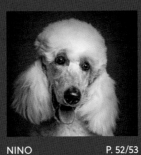

DONATELLA P. 48/49 ELLA P. 50/51 NINO P. 52/53 EMMI P. 54/55

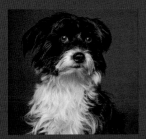

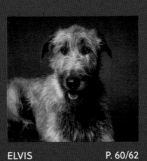
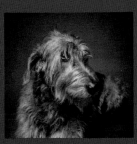

FRANZI P. 56/57 FREDDIE P. 58/59 ELVIS P. 60/62 EMMA P. 61/62

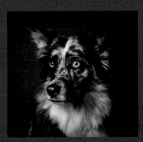
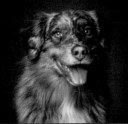
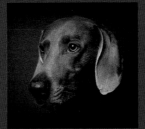
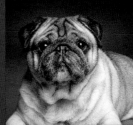

MISTERY P. 63/64 SPICY P. 63/65 GINGER P. 66/67 GISBERT P. 68/69

INDEX

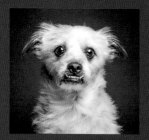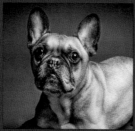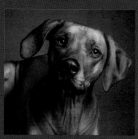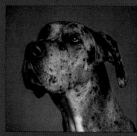

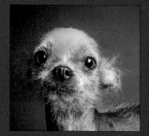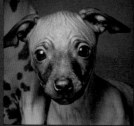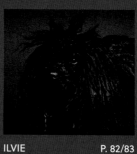

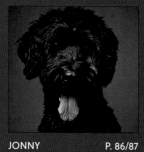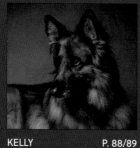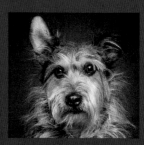

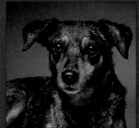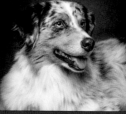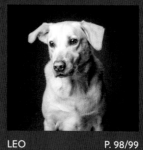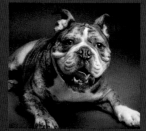

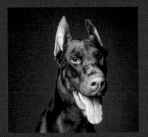
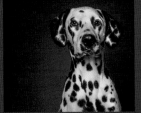
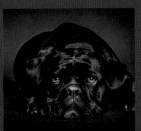
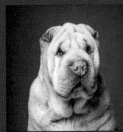

ROMERO P. 102/103 LODOS P. 104/105 LOTTE P. 106/107 LUCA P. 108/109

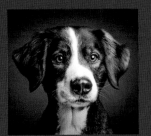

MAJA P. 110/111 MERLE P. 112/113 MERLIN P. 114/115 MEXX P. 116/117

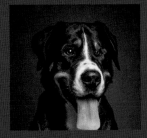
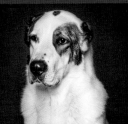

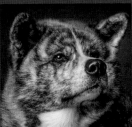
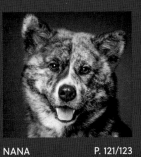

MILOW P. 118/120 BOMBER P. 119/120 RYUU P. 121/122 NANA P. 121/123

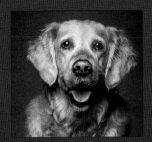
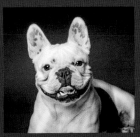
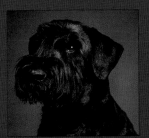
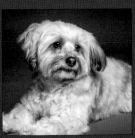

INDEX

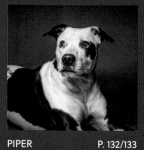

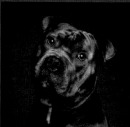

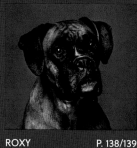

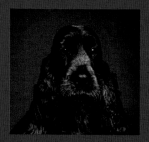

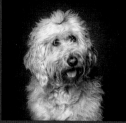

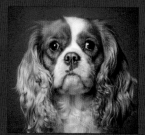

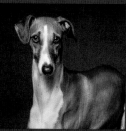

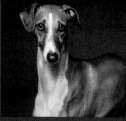

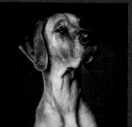

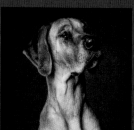

WOODY P. 156/157

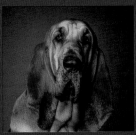

HILDE P. 158/160

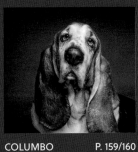

COLUMBO P. 159/160

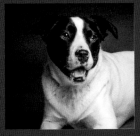

MÖHRE P. 161/162

DORI P. 161/163

AKITA P. 164/165

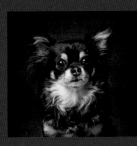

GISMO P. 166/167

SANDRA MÜLLER

Sandra Müller bought her first SLR camera at 14. She has been a big animal lover since childhood – from guinea pigs to her aunt's dog, with whom she spent entire summer vacations. Today, she is the proud owner of Maja, the "most beautiful Bernese Mountain Dog mix in the world," and has found her calling in photography. She specializes in portraits of people and dogs. She feels it is very important to capture the unique personality of each of her subjects, two-legged or four-legged, in each shot. She lives in Haimendorf (near Nuremberg), Germany.

Sandra Müller kaufte sich mit 14 Jahren ihre erste Spiegelreflexkamera. Und schon als Kind liebte sie Tiere, vom Meerschweinchen bis zum Hund ihrer Tante, mit dem sie ihre gesamten Sommerferien verbrachte. Heute ist sie stolze Besitzerin von Maja, der „schönsten Berner-Sennenhund-Mix-Hündin der Welt", und hat in der Fotografie ihre Berufung gefunden. Ihre Spezialität sind Porträts von Menschen und Tieren. Dabei ist es ihr besonders wichtig, bei jedem Bild auf den individuellen Charakter des Abgebildeten – egal ob Mensch oder Tier – einzugehen. Sie lebt in Haimendorf bei Nürnberg.

Sandra Müller s'est acheté son premier appareil photo Reflex à l'âge de 14 ans. Toute petite déjà, elle avait une passion pour les animaux, son cochon d'Inde d'abord et jusqu'au chien de sa tante qu'elle ne quittait pas de toutes les vacances. Aujourd'hui, elle est très fière d'être la maîtresse de la chienne Maja, le « plus beau bouvier bernois mâtiné au monde » et a trouvé sa vocation dans la photographie où elle s'est spécialisée dans les portraits d'humains et d'animaux. Et pour elle, la règle absolue est de respecter pour chaque photo l'individualité – qu'il s'agisse d'un humain ou d'un animal. Elle vit à Haimendorf, près de Nuremberg (D).

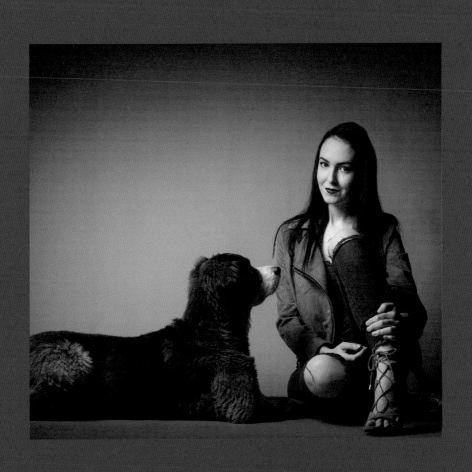

© 2020 teNeues Verlag GmbH
Photographs © 2017 Sandra Müller
www.sandramuellerfotografie.de
All rights reserved.

Author/Photography:
Sandra Müller
Editorial coordination/text:
Stephanie Bräuer
Translations:
Amanda Ennis (English)
Florence Papillon (French)
Art Direction:
Martin Graf
Production:
Sandra Jansen-Dorn
Color separation:
Jens Grundei

ISBN 978-3-96171-293-9
Library of Congress Control Number: 2020935919

Picture and text rights reserved for all countries.
No part of this publication may be reproduced in
any manner whatsoever.

While we strive for utmost precision in every detail,
we cannot be held responsible for any inaccuracies,
neither for any subsequent loss or damage arising.

Every effort has been made by the publisher to
contact holders of copyright to obtain permission
to reproduce copyrighted material. However, if any
permissions have been inadvertently overlooked,
teNeues Publishing Group will be pleased to make
the necessary and reasonable arrangements at the
first opportunity.

Bibliographic information published by the
Deutsche Nationalbibliothek: The Deutsche
Nationalbibliothek lists this publication
in the Deutsche Nationalbibliografie; detailed
bibliographic data are available on the Internet
at dnb.dnb.de.

Printed in the Czech Republic by PBtisk a. s.

Published by teNeues Publishing Group

teNeues Verlag GmbH
Werner-von-Siemens-Straße 1
86159 Augsburg, Germany

Düsseldorf Office
Waldenburger Str. 13, 41564 Kaarst, Germany
e-mail: books@teneues.com

Augsburg/Munich Office
Werner-von-Siemens-Straße 1
86159 Augsburg, Germany
e-mail: bbarlet@teneues.com

Berlin Office
Lietzenburger Str. 53, 10719 Berlin, Germany
e-mail: ajasper@teneues.com

Press department: Stefan Becht
Phone: +49-152-2874-9508
 +49-6321-97067-99
e-mail: sbecht@teneues.com

teNeues Publishing Company
350 Seventh Avenue, Suite 301, New York
NY 10001, USA
Phone: +1-212-627-9090
Fax: +1-212-627-9511

teNeues Publishing UK Ltd.
12 Ferndene Road, London SE24 0AQ, UK
Phone: +44-20-3542-8997

www.teneues.com

teNeues Publishing Group
Augsburg / München
Berlin
Düsseldorf
London
New York

teNeues